Alexander Calder

BY HOWARD GREENFELD

THE WONDERLAND
PRESS

Harry N. Abrams, Inc., Publishers

THE WONDERLAND PRESS

The Essential™ is a trademark
of The Wonderland Press, New York
The Essential™ series has been created by The Wonderland Press

Series Producer: John Campbell
Series Editor: Harriet Whelchel
Series Design: The Wonderland Press

Library of Congress Catalog Card Number: 2002114123
ISBN 0-8109-5834-1 (Harry N. Abrams, Inc.)

CREDITS

ART RESOURCE, NY: Pages 4, 7, 10, 13, 18, 32 (both images), 37, 44, 50 (wire sculpture), 52, 53 (both images), 56, 59, 60, 65, 66, 72, 73, 74, 80, 82 (both images), 84, 86–87, 89, 92, 93 (SCALA/ Art Resource), 98–99, 104, 107, 112, Jacket, Endpapers
CHRISTIES IMAGES: Pages 8–9, 14–15, 70, 103

Whenever a museum collection is not credited, the work of art belongs to a private collection

On the endpapers: The Rattle Cat. 1969. Sheet metal and paint. 8 x 34 x 7". Private collection

Printed and bound in China

Harry N. Abrams, Inc.
100 Fifth Avenue
New York, NY 10011
www.abramsbooks.com

Abrams is a subsidiary of

LA MARTINIÈRE
GROUPE

Contents

An important **dinner** ...5

Art everywhere ...10

Animals ...13

Off to **work** ...17

A major **revelation** ...19

Studying art ...21

The **circus** calls ...24

Paris beckons ...29

Wire and wood ...33

"Ladies and gentlemen" ...36

Sculpting with wire ..44

Celebrity arrives ...50

Marrying his soulmate ..52

Going **abstract** ...58

The **mobile** is born ...67

A major **commission** ..79

And now, the **stabile** ..82

Monumental works ..97

Alexander the Great ..107

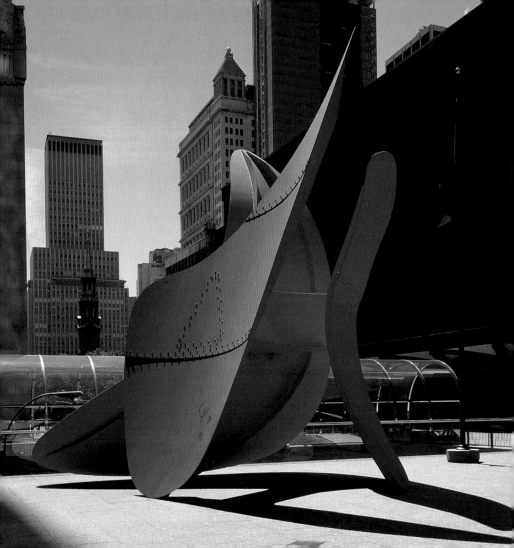

A Dinner at the Whitney

On the night of October 20, 1976, a dinner was held at New York City's Whitney Museum of American Art to honor **Alexander Calder** (1898–1976), the most celebrated and beloved of all American sculptors. The occasion was the opening, a few days earlier, of a large retrospective of the artist's works.

The guests included some of Calder's most enthusiastic friends and admirers: Arthur Miller, Georgia O'Keeffe, Philip Johnson, Louise Nevelson, Marcel Breuer, John Cage, Merce Cunningham, Virgil Thomson, and Robert Penn Warren. Only three weeks later, the 78-year-old sculptor was dead.

It could be said that the course of modern sculpture had been dramatically altered by this perpetual child—a round-bellied, roaring, and tinkering grown-up known all his life as "Sandy" Calder (most probably to differentiate him from his father and grandfather, both of them named Alexander).

Warm and witty, he often played practical jokes on—and forever brought pleasure to—both friends and strangers. He was an artist who, seemingly without effort (but only seemingly), created marvelous works of art with the same abundance with which he ate, laughed, and drank.

OPPOSITE
Bent Propeller. 1970
Sheet metal, bolts, and paint.
Height: 25 feet (7.625 meters)
Destroyed on September 11, 2001 during the attack on the World Trade Center, New York

5

A Life of their own

Calder's life was as filled with humor and joy and freedom as were the *mobiles* for which he was well known: Hanging, dangling, yet perfectly balanced, these innovative forms of sculpture usually consisted of various pieces of different sizes, shapes, and colors, and would swing on a breeze, twisting and orbiting, seeming to have a life of their own. (See *Eleven Polychrome* on pages 8 and 9 as an example.)

A Family of sculptors

There is probably no such thing as a "born" artist, but Alexander Calder, born on July 22, 1898, in Lawnton, Pennsylvania (now a part of Philadelphia), certainly seemed destined to become one. Many of his ancestors were artists. His paternal grandfather, **Alexander Milne Calder**, who was born in Scotland in 1846, had emigrated in 1868 to Philadelphia, where he studied at the Pennsylvania Academy of Fine

Arts and became a successful sculptor, best known as the creator of the huge—thirty-six feet tall—monumental statue of William Penn, which took him twenty years to complete and which stands atop Philadelphia's City Hall.

Sandy's father, **Alexander Stirling Calder** (1870–1945), born in Philadelphia in 1870, also achieved considerable fame as a sculptor. Following his own father's footsteps, he enrolled at the Pennsylvania Academy of Fine Arts at the age of sixteen and studied drawing with the great painter **Thomas Eakins** (1844–1916). He then traveled to Europe and spent two years in Paris, where he studied both painting and sculpture before returning to Philadelphia to pursue his career as a sculptor. He is known today for having carved the figure of George Washington as a statesman on the arch in New York City's Washington Square Park. Sandy's mother, Milwaukee-born **Nanette Lederer Calder**, three and a half years older than her husband, was also an artist. She, too, had studied at the Pennsylvania Academy of Fine Arts and was a distinguished portrait painter.

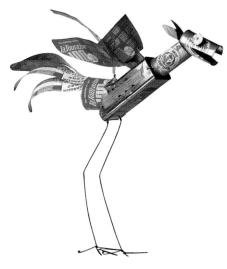

La Touraine. c. 1965
Tin cans and wire
32 ¼ x 21 ⅝ x 30 ⅝"
(81.9 x 57.7 x 77.8 cm)

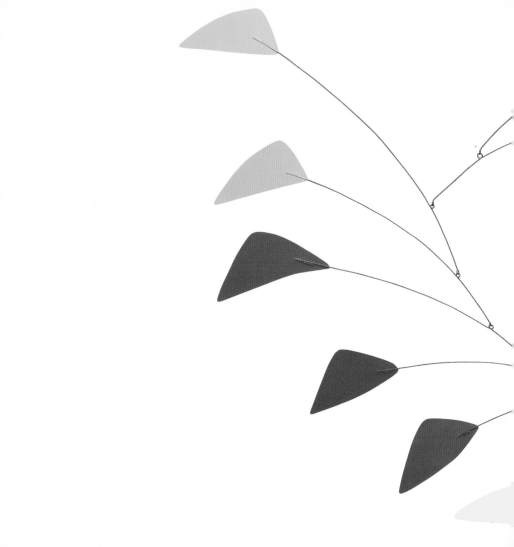

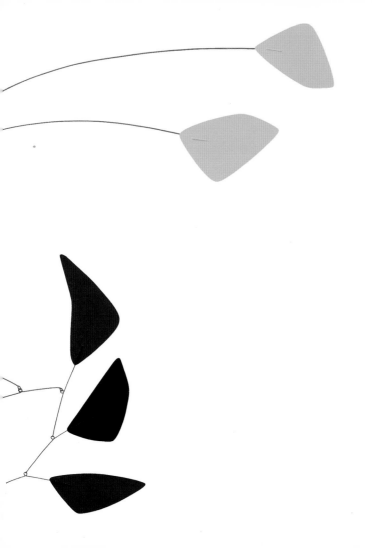

Eleven Polychrome
1961. Painted sheet
metal and rod.
Height: 41" (104.2 cm);
span: 54" (137.2 cm)

A houseful of art

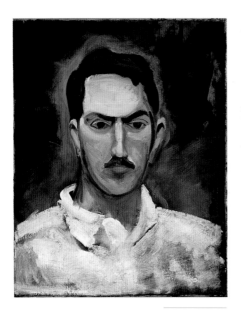

Self-Portrait. 1925
Oil on canvas
20 x 16" (50.8 x 40.6 cm)

Sandy was the second of the couple's two children. His sister, **Margaret (Peggy) Calder,** had been born two and a half years earlier—in 1896—in Paris, where their parents had gone following their wedding in February 1895, and where they had remained until shortly before the birth of their son.

The Calder household was the ideal atmosphere in which to cultivate an interest in art. Paintings and sculptures were everywhere to be seen and were frequently the topic of impassioned conversation in the family and among their friends, many of whom were themselves artists. It was therefore natural that young Sandy should also become attracted to this world. Though he rarely worked with his father or in his father's studio (where he did, however, sculpt a clay figure of an elephant when he was only four years old), he showed an extraordinary creative

drive even as an infant. This led him to manipulate materials of all kinds, mainly scraps, into more or less recognizable forms.

In spite of the success that Sandy's father had as both a sculptor and a teacher, the Calder family had little financial security. Because of this, they were often on the move, depending on the requirements of the senior Calder's career. As a sculptor known for his monumental works, he was always in search of public commissions, and as a man in fragile health—he had contracted tuberculosis in 1905—he was frequently in need of a gentle climate.

Consequently, by the time the enthusiastic, fun-loving Sandy was seventeen, he had lived in ten different houses and apartments throughout the United States. Beginning in 1905, the Calders traveled from one coast to the other—from Philadelphia to Oracle, Arizona; to Pasadena, California; back to Philadelphia, and on to the area around New York City; and then to San Francisco—until 1915, when the family moved back to New York City itself. During this lengthy period, Sandy's desire to create works of art, from whatever materials, persisted and grew. It was not a chore but a joyful necessity.

A workshop wherever they lived

His parents encouraged his artistic creations and provided him with a workshop wherever they lived. They gave him tools—the first ones

Alexander Calder
on the beach in
California with his
mother, Nanette
1909

while living in Pasadena in 1906. While there, he used the cellar of their home as his first workshop, making jewelry from copper wire and beads for his sister's dolls. This workshop became a center of attraction; everybody came in. His sister Peggy once gave him a very nice pair of pliers at Christmas (pliers later became a favorite tool, used to create wire sculptures), and he made her a little Christmas tree, completely decorated, out of a fallen branch.

A tent with a wooden floor served as his workshop in a second Pasadena home, where they moved in 1909. For Christmas that year, he gave his parents a little dog and duck he had made of sheet brass, cutting the metal out flat and then bending it so that the dog stood on four legs. To commemorate his father's birthday the following January, the eleven-year-old boy made a little game out of wood, a rectangle divided into six pens by nails, with a tiger, a lion, and three bears—all painted—fastened into slots so that they could be moved from one pen to another.

The purpose of the game was to clean the pens without having two animals in the same pen at once in order to prevent bloodshed.

Animals, animals

From his earliest years, Sandy was intrigued with animals—and especially with their shapes and movements. He created a lion's cage by trimming a milk crate with ribbons; he improvised a Noah's ark and he created a number of imaginary household pets. Even though these were the works of a child and not mature works of art, they provided an early indication of the direction that the youngster's creativity would take.

In June of 1915, the elder Calder was named acting chief of the Department of Sculpture at the Panama-Pacific International Exposition in San Francisco. There, he was given a large studio that young Sandy would frequently visit.

Back to New York City

In August 1915, the family once again returned to New York City. This time they found an apartment in the city

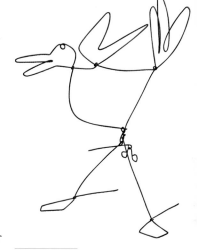

ABOVE
Bird. c. 1926. Wire
11 x 9 ³/₄ x 8"
(27.9 x 24.8 x 20.3 cm)

OVERLEAF
Fish. c. 1942. Painted rod, wire, glass, porcelain, and string. Height: 15" (38 cm); span: 36 ¹/₂" (92.7 cm)

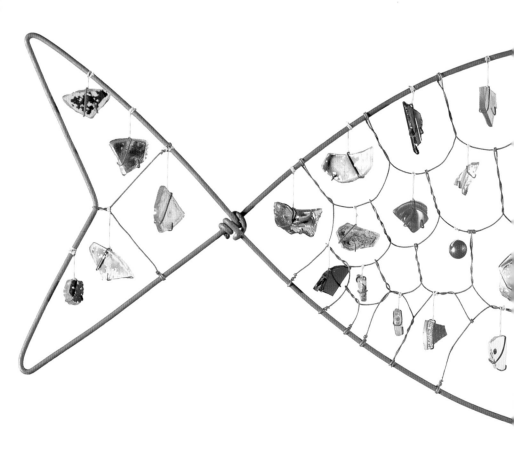

itself, near Barnard College, where Peggy continued to attend classes—she had started her college career at the University of California. At the same time, Sandy, having graduated from high school in San Francisco, planned to begin his studies at the Stevens Institute of Technology in Hoboken, New Jersey. The difficult decision to attend a technical school rather than a liberal arts college had been made shortly after his high school graduation. Though he obviously showed talent as an artist, he was not yet prepared to devote a large part of his life to the study of art. Moreover, his parents were aware of the financial difficulties that he would inevitably encounter along the way, and they attempted to discourage him from pursuing a career as a professional artist.

What's a mechanical engineer?

Meanwhile, Calder chose to follow an unexpected path. After learning that a fellow high school graduate was planning to study mechanical engineering, he decided, for no apparent reason, that he would do the same—though he later confessed that at the time he made the decision he didn't really know what mechanical engineering was.

Still, his decision was a good one since engineering would prove to be enormously important in the development of Calder's unique creativity. The engineering curriculum at Stevens included a laboratory in mechanical engineering and a course in applied kinetics, both of which were invaluable to his growth as an artist. The young man excelled in these as well as in mechanical drawing, drafting, and descriptive geometry.

"Sandy-child" graduates and goes to work

In addition to his academic successes, Calder also enjoyed himself socially. He was popular with his classmates and played football and lacrosse just for sheer physical pleasure. As for dancing, one of his classmates noted that "nobody whirled the girls more rapidly." The classmate added that he never heard Sandy make an unkind or derogatory comment about anyone unless he witnessed an injustice to a student or professor.

Calder graduated from Stevens on June 17, 1919, and undertook a number of jobs that led him to different parts of the country. He worked as an automotive engineer in Rutherford, New Jersey (this lasted two weeks), and then as a draftsman at the New York Edison Company, a job he found unbearably dull. In the fall of 1920, he traveled to Saint Louis, Missouri, where he spent nine months working unsuccessfully for a journal called *Lumber,* after which he found employment coloring maps for a hydraulic engineer in Bridgeport, Connecticut.

A night class

By the spring of 1922, Sandy had returned to New York City, having grown weary of this succession of tedious jobs. Although he had been a brilliant student of engineering, he was now convinced that he could not successfully pursue a career as an engineer and that he was ill-suited to any job that tied him to an office.

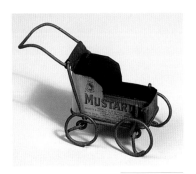

Baby Carriage. c. 1940
Tin can and wire
2 ³⁄₈ x 4 ¹⁄₄ x 2 ¹⁄₄"
(6.03 x 10.80 x 5.72 cm)

His first, tentative step toward becoming a professional artist occurred when he enrolled in a night-school class in drawing. Sandy was far more enthusiastic about the drawing class than he had been about any of his post-Stevens endeavors. He found it stimulating to be part of a group that shared his interest in art, and he gradually distanced himself from the future engineers with whom he had become acquainted at college.

Yet Calder was still not ready to make a serious commitment to a profession, whether it be engineering or art. He was restless to move about. So, not long after returning to New York City, he signed up as a fireman in the boiler room of a passenger ship, the HF *Alexander*, which was sailing from New York to San Francisco via the Panama Canal. His Seaman's Certificate, dated May 22, 1922, describes him as being 23 years old and 5'10" tall, with hazel eyes and dark brown hair, and having a ruddy complexion.

Sandy at sea

The ship was a large one, with more than 700 passengers and a crew of about 1,000. The men slept in hammocks in airless, cramped quarters in the front of the

ship, but Sandy overcame this problem by sleeping—when off duty—on great coils of rope on the deck. This allowed him to sleep in the fresh air, and it also gave him the opportunity to contemplate the sky and stars. The inexperienced young seaman proved to be inventive in other ways as well: He showed a talent for devising makeshift tools, for example, hammering out a scraper in the ship's workshop in order to alleviate the shortage of penknives (since there was only one penknife for five or six firemen).

A major revelation

As Calder would later describe in his autobiography, *Calder: An Autobiography with Pictures* (1966), the beauty and drama of one particular experience that he had onboard would have a profound influence on him: "It was early one morning on a calm sea, off Guatemala, when over my couch—a coil of rope—I saw the beginning of a fiery red sunrise on one side and the moon looking like a silver coin on the other. Of the whole trip, this impressed me most of all; it left me with a lasting sensation of the solar system." His art, for the rest of his life, would reflect the mechanics of the universe: "The basis of everything for me is the universe. The simplest forms in the universe are the sphere and the circle. I represent them by discs and then I vary them…spheres of different sizes, densities, colors, and volumes, floating in space, traversing clouds, sprays of water, currents of air, viscosities and odors—of the greatest variety and disparity."

Logging and landscapes

In the middle of June 1922, when the HF *Alexander* reached San Francisco, Calder realized that he had had enough of the boiler room and decided to leave the ship. He traveled on to the state of Washington, where he joined his sister Peggy and her husband, Kenneth Hayes, at American Lake, a small lake on the prairie near Tacoma. In August, the family returned to the Hayeses' home in Aberdeen, a town of sawmills, logging trains, and logging ponds.

Once again, Sandy was faced with the problem of finding a job, but his brother-in-law found him employment as a timekeeper at a logging camp in nearby Independence. The work was of little interest, but Sandy was fascinated by the ingenious techniques used in logging. Most important, he was so moved by the spectacular landscape that he suddenly felt an urge to paint again. The desire to resume painting was so great that he wrote home and asked that paints and brushes be sent to him—a small step but a significant one.

Before long, a dispute with the foreman prompted Calder to move on to another camp, where he was employed as a draftsman. Since this position made use of the training he had received as an engineer, it was somewhat more satisfying than his previous jobs. However, he knew that he did not want to spend the rest of his life as a draftsman or as an engineer. It was time to make a serious commitment to a career: Calder decided to devote his studies and his life to becoming an artist.

The Art Students League

In the fall of 1923, the 25-year-old Calder returned to New York and enrolled in the Art Students League, perhaps the most distinguished art school in the United States during the early part of the 20th century. It was managed and controlled by its students and had no set course of studies or academic requirements.

The school attracted fine teachers, many of whom were also distinguished painters. As artists, they were conservative realists, apparently untouched by the European Modernism that was beginning to influence American art, but as teachers they advocated complete freedom of artistic expression and encouraged their students to experiment in whatever style they wished.

Calder was able to study with **John Sloan** (1871–1951), a printmaker and poster artist as well as a brilliant painter. Sloan was the most political of the realists and was a friend of the Calder family. **Guy Pène du**

Bois (1884–1958) was another instructor with whom Calder studied for several months and whose art Calder especially admired.

Sandy remained at the Art Students League from 1923 to 1926. He was industrious and diligent and enjoyed his studies. Most of the work he produced during those years showed the influence of his teachers and gave no indication of the direction his future art would take. His principal subjects were the people and places of New York City. While traveling around the city, he carried pieces of wrapping paper on which he sketched or painted subway travelers, ships in the harbor, steers in the stockyards, scenes from the Democratic Convention of 1924, and views of Madison Square Garden and the Brooklyn Bridge.

Sandy at school

Sandy had little money during his years at art school—not nearly enough to be able to devote himself full time to his studies and to his painting, as he would have liked. His various jobs included shifting scenery in a Greenwich Village theater, making picture frames and light fixtures, and trying (unsuccessfully) to design envelopes, paint matchbook covers, and embellish banjos with images of bathing beauties. He did, however, find one job that made use of his talent as a draftsman, and particularly of his skill at drawing moving figures: He decorated A. G. Spalding, a sporting goods store on Fifth Avenue, with drawings of athletes in action—for which he was paid the relatively smart sum of $150.

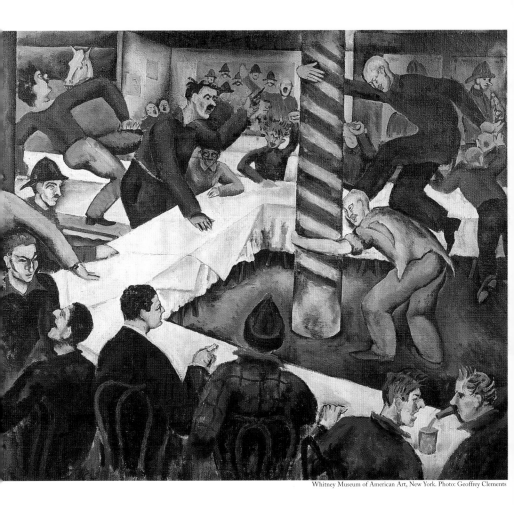

Sandy Calder goes a-sketching

In 1924, while he was still a student at the Art Students League, Sandy was hired as an illustrator for the *National Police Gazette*, a weekly magazine devoted to sports and entertainment. His first assignment was to draw boxers at Madison Square Garden, and this led to jobs illustrating baseball games, bicycle races, and prize fights. Calder developed rapidly as an artist, and since he had little space of his own, his work was piled up in his father's spacious studio. There were dozens of large canvases—sketches, street scenes, caricatures, faces and figures (of humans and animals), and many drawings of the Ringling Brothers and Barnum & Bailey Circus (see right), which, with the aid of a pass from the *National Police Gazette,* he attended almost every day and night for two weeks.

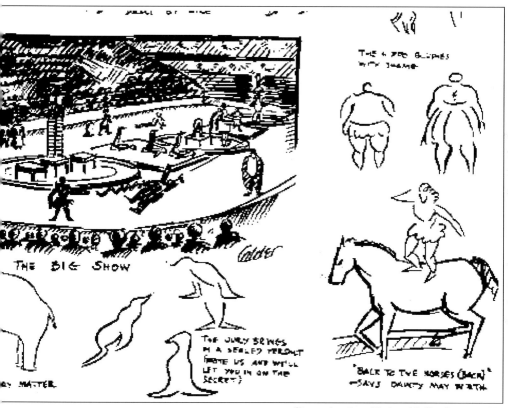

Circus drawing, *National Police Gazette,* 1924

A wild rooster

In his moments away from school, Sandy continued to pursue that special gift for creativity and innovation that had characterized him since his early childhood, and this led to the creation of his first wire sculpture. In describing the small, narrow bedroom in which he lived on 14th Street, Sandy wrote that his room had no clock and faced south, so he made a sundial with a piece of wire, in the form of a wire rooster on a vertical rod, with radiating lines at the foot that indicated the hours: "I'd made things out of wire before—jewelry, toys—but this was my first effort to represent an animal in wire."

"One must *arrive!*": First Exhibitions

Sandy now devoted himself enthusiastically to pursuing a career as an artist. Because of his father's experience and that of the many

artists who visited the Calder home, he understood the difficulties and struggles involved in making a living solely through his art. Nevertheless, he was determined to make every sacrifice to free himself from the need to take on boring part-time jobs. When Marie Sterner, a New York dealer, expressed a willingness to show one of his canvases in an exhibition of American painting to be held in Paris—on the condition that he would pay to have the work shipped overseas—he readily agreed. "What the hell," he wrote to his sister Peggy. "If one doesn't show things, one doesn't *arrive* and one must *arrive!*"

Since the time of his arrival in New York City, he had had opportunities to show his paintings at a few group exhibitions, but none of his works had sold. In 1925, he had joined the Society of Independent Artists, a group in which his father had been a member and of which John Sloan was the president at the time Calder was studying at the Art Students League. The organization had been founded in 1916 and had become the mainstay of American Modernism. It offered non-juried exhibitions to American artists whose work was not accepted by more conventional, "establishment" groups.

The year 1926 was eventful. Sandy made his first wood sculpture, *Flat Cat*, carved from an oak fence rail while visiting the home of a friend in Connecticut; he had a book, *Animal Sketching*, published, a manual for art students that shows his extraordinary skill as a draftsman; and his name was, for the first time, mentioned in the national press. Commenting on an exhibition held at the Artists Gallery, *The New Yorker*'s

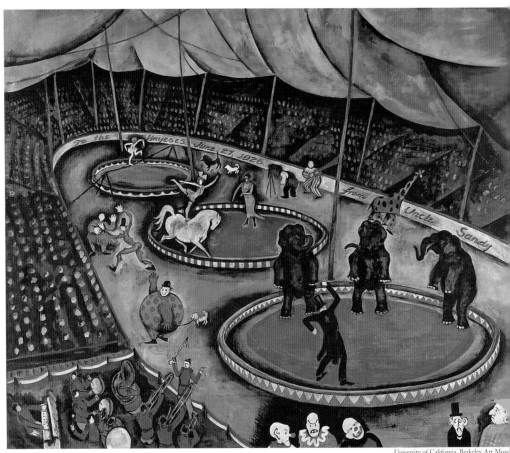

Text visible within the artwork: "To the Hayeses June 27, 1926 from Uncle Sandy"

Murdock Pemberton wrote about safe investments in art, noting that "minor canvases can be had for little money, and your grandchildren can sell them for much." The reviewer concluded that "a Calder, too, we think is a good bet."

To Paris

That year marked a major turning point for the young artist. On July 2, 1926, restless for a change of scenery, Calder sailed for Europe. It was his first visit to Paris and was the right move at the right time. Both of his parents had studied art in Paris and they encouraged their son to do so, as did his instructors and his fellow students. More than any city in the world during the 1920s, the French capital offered the right climate for an artist, a musician, or a writer.

Gertrude Stein (1874–1946), the legendary American writer who had gone to Paris in 1903, wrote that it was "the place that suited those of us who were to create the 20th-century art and literature." In the early years of the 20th century, Paris had witnessed the birth of many new movements, especially in art and literature. Before World War I, there was Cubism—a true revolution in art, led by **Pablo Picasso** (1881–1973) and **Georges Braque** (1882–1963). Music and dance had been integrated and invigorated in an altogether new way with the many appearances in the French capital of the Russian Ballet ("Ballets Russes"), led by **Sergei Diaghilev** (1872–1929), who brought together the greatest figures in all

OPPOSITE
Circus Scene. 1926
Gouache on fabric
mounted on
cardboard panel
69 3/4 x 83 1/2"
(177.2 x 212.1 cm)

three fields—Picasso, the composer **Igor Stravinsky** (1882–1971), and the magnificent Russian dancer **Vaslav Nijinsky** (1890–1950).

In the years after World War I, English-language writers from all over the world—**Ernest Hemingway** (1899–1961), **F. Scott Fitzgerald** (1896–1940), and **James Joyce** (1882–1941) among them—had come to live and work in Paris in a climate eminently suitable for their creative growth.

Painters, too, had flocked to the city from other countries, both before and after the war. Their numbers included **Marc Chagall** (1887–1985) from Russia, **Amedeo Modigliani** (1884–1920) from Italy, **Chaim Soutine** (1894–1943) from Lithuania, **Joan Miró** (1893–1983) from Spain, **Piet Mondrian** (1872–1944) from Holland, and the sculptor **Constantin Brancusi** (1876–1957) from Romania. Of all cities, Paris was the most receptive to new ideas and currents in the arts. Dada, a movement that had been born in Switzerland, moved officially to Paris in 1920, where it soon died and was succeeded by Surrealism, a more robust and influential literary and artistic movement. Art galleries were flourishing, and the possibilities for a painter or sculptor finding a place in which to exhibit his or her work were far greater than they would have been elsewhere.

American artists who came to Paris in increasing numbers during the 1920s had special reasons to do so, especially economic. Transatlantic fares were low and the value of the dollar was higher than ever compared to the failing French franc. Lodging was easy to find—and at far lower rent than it would have cost at home. Food, too, was relatively inexpen-

sive, and there was another—not unimportant—factor that appealed to American expatriates: The 1920s were the years of Prohibition, when the manufacture and consumption of alcohol were forbidden in the United States. In Paris, Americans were free to drink whatever they wished, dress as they pleased, keep the hours best suited to them, and have the lovers they wanted. Sandy Calder had another reason to appreciate Paris: There, he believed, it was a compliment to be called *crazy*.

Sound Byte:

Instead of sitting on the seat of the bench, Calder was sitting on the top of the back support with his feet on the seat part so he could get a better view of the tables and crowd on the terrace. He had a sketch pad in one hand and a pencil or pen in the other and he was making a drawing of someone on the terrace. He would look at the person…and then draw. And as he would draw and then look up again, the mass of two or three hundred people on the terrace would look at him. He was serious (at least his expression was) and they were too. He kept working and the mass of people (which by that time seemed like thousands) cooperated with him. They all held a dignified pose, even though his interest was concerned with only one…. It would have embarrassed me to have done that. But nothing ever embarrassed Calder. He just was not that self-conscious.

—CLAY SPOHN, one of Calder's former classmates from the Art Students League, on observing Calder at the Dôme Café in Paris

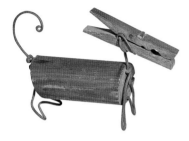

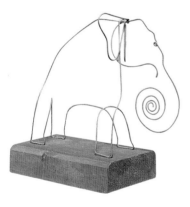

Cantaloupe with the straw hat

Calder arrived in Paris on July 24, 1926, a stranger with no professional contacts or friends—only a few acquaintances from the Art Students League. He did not speak French, and he had little money beyond the $75 per month that his mother had offered to send him. He did, however, possess extraordinary charm, warmth, and humor and had no trouble meeting and delighting those who came into contact with him. In short order, he began taking French lessons and enrolled at the Académie de la Grande Chaumière, a well-known and unstructured art school, where he applied himself diligently to several hours of drawing classes per day. Soon after arriving in Paris, Calder found his way to Montparnasse, in the central part of the city, where most of the artists had made their homes, in part because of its lively cafés and popular meeting places.

It was Sandy's lack of self-consciousness—together with his great charm, his never-ending good nature, and his contagious laughter—that enabled the exceedingly affable newcomer to make friends and establish contacts during his first months in Paris. He did so in part by shamelessly, but endearingly, calling attention to himself. For instance, he was seen wearing an orange suit and

straw hat that caused amused observers to call him the "cantaloupe with the straw hat."

Toys of wire and wood

After three weeks in Paris, Sandy found a small studio close to the center of Montparnasse. Unfortunately, the small amount of money that his parents had sent him was not enough to cover his expenses. He had to pay for French lessons and for drawing classes; art supplies were costly, and his rent was higher than he had anticipated.

It was difficult to find reasonably well-paying part-time jobs, but soon he accepted a job with the Holland-America Line, making drawings of the activities on board one of its ships during the course of a round-trip crossing to New York City—largely for use in an advertising brochure. Back in Paris, he took on odd jobs for a number of advertising agencies and occasionally made portraits of buyers for American stores for the European edition of the *New York Herald*. He also submitted drawings to *The New Yorker*.

Calder lacked enthusiasm for the drawings he had worked on in his studio, and even his interest in painting had diminished. The act of renting the studio had filled him with pride at the idea of being a painter with his own work space in Paris, but during his time there, he was unable to complete even one canvas to his satisfaction. The outlet for Calder's astounding creativity was turning from painting and drawing to sculpture—but not to the conventional sculpture of his ancestors. Sandy's was different.

OPPOSITE ABOVE
Dog. c. 1927
Wood, wire, and clothespin
Height: 2 ½"
(5.08 cm);
length: 4" (10.16 cm)

OPPOSITE BELOW
Elephant. c. 1928
Wire and wood
11 ½ x 5 ¾ x 11 ½"
(29.2 x 14.6 x 29.2 cm)

33

It had started, when he was very young, with toys—with wire, wood, cork, leather, rubber, the soft insides of bread, cloth, or any material that he could manipulate into a plaything or an imaginative, witty object. Before coming to Paris, he had briefly turned his hobby into a job, working on a humpty-dumpty circus for a Philadelphia toy company. Sandy had also fashioned the sundial/rooster in New York—his first attempt at wire sculpture—and had carved the wooden cat in Connecticut, his first wood sculpture. Now, in Paris, for his own pleasure he resumed making creatures, both human and animal, made largely of wood and/or wire.

Sound Byte:
There was an elephant and a mule. They could be made to stand up on their hind quarters, front quarters, or heads. Then there were clowns with slots in their feet and claws in their hands; they could balance on a ladder or one foot or one hand.

—ALEXANDER CALDER, recalling his creation of an early circus

Because he found such joy and satisfaction in creating these fanciful figures, it is not surprising that, a short time after moving into his studio, Sandy took the decisive step of building a small workbench and acquiring a few tools, along with some wire and some wood. It was time to exchange his paints, brushes, and canvases for some carving instruments, reels of wire, and a pair of pliers.

Calder soon learned that he could earn a living more easily from the wire and wood figures he created than he could from his drawings. Visitors to his studio were enchanted by these witty and colorful figures, usually made of a combination of materials—wood and wire, tin, leather, or of anything that caught his fancy. Through friends, he was introduced to a Serbian toy dealer who suggested he could earn money by making some movable-jointed toys, which he did enthusiastically. The Serb disappeared, but the experience was of value, since, as a result of it, Calder was hired by the Gould Manufacturing Company of Oshkosh, Wisconsin (which he visited in the fall of 1927), to design a new line of action toys. Among other products, the company manufac-

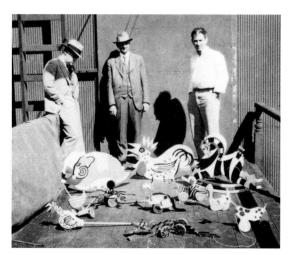

Alexander Calder with a series of his animal "Action Toys" at the Gould Manufacturing Company, Oshkosh, Wisconsin. Fall 1927

tured doors, using plywood and thicker woods, and Calder employed these scraps in creating his toys: brightly painted animals attached to wheels that included a wiggling goldfish, an acrobatic bear, a goring bull, and Quackie Toddler, who clapped his bill loudly. These toys were a commercial success and earned their creator a modest but steady royalty that increased as sales grew.

The Circus master

The same spirit of playfulness exhibited in these toys was present in the work that remains one of the sculptor's most famous: a collection of his figures, ingeniously manipulated by their maker, that has become known as the *Cirque Calder* ("Calder's Circus"), the culmination of his lifelong fascination with both the circus and handmade playthings.

At first, Sandy showed these figures to only a few friends. As the number of figures grew—along with the number of friends and acquaintances—he invited everyone he could to view his miniature circus. He sent out written invitations and began charging admission. Elizabeth Hawes, a friend who witnessed an early performance, wrote that the circus tent was "a two-by-four room, the audience sat on the bed, slightly in fear of one of the hundred toys that hung on the wall falling on their collective head, and Sandy, sitting on the floor, set up the rigging with all the care of a combination engineer, child-with-its-favorite-toy, and creator."

A piece of carpet was unrolled, and poles were set up to support the trapeze to be used by the aerialists. A spotlight was shone on the ring, and a record album was placed on the small phonograph. Then, Calder the circus master would announce: "Mesdames et messieurs, je vous présente…" and the show would begin.

At first, the cast of characters was small and the show lasted no more than a quarter of an hour. However, as the fame of this unique enter-

Alexander Calder with his *Cirque Calder.* 1927

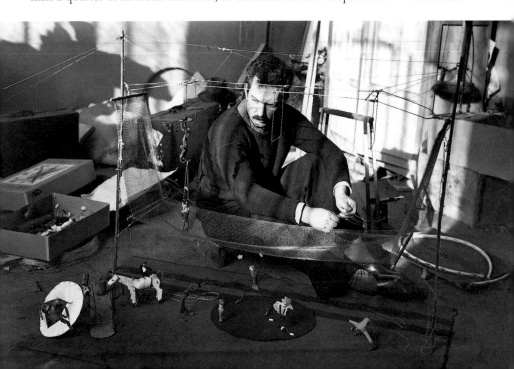

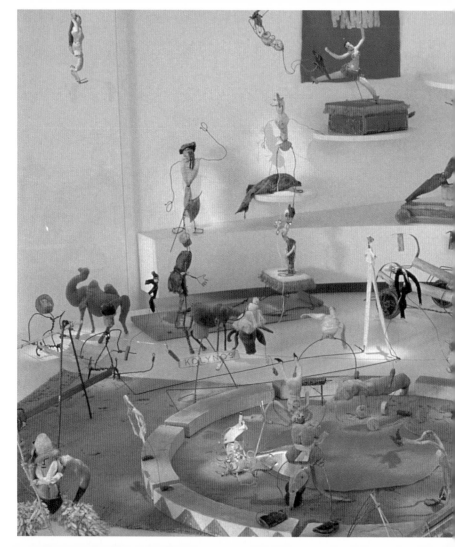

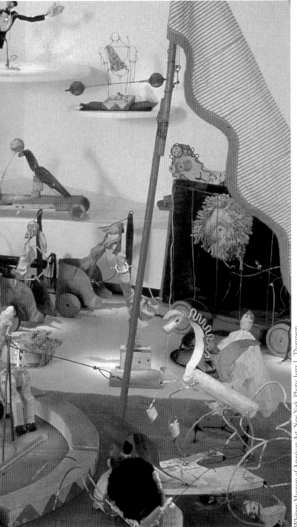

Calder's Circus ("Le Cirque Calder") 1926–31. Mixed media: wire, wood, metal, cloth, yarn, paper, cardboard, string, rubber tubing, corks, buttons, rhinestones, pipe cleaners, bottle caps. Dimensions variable, overall: 54 x 94 $\frac{1}{4}$ x 94 $\frac{1}{4}$" (137.2 x 239.4 x 239.4 cm).

tainment spread throughout Montparnasse and beyond, Sandy moved to a much larger studio. Before long, more and more visitors came to witness what had gradually become an elaborate two-hour show performed by some seventy figures—most of them about six inches tall and made of wire, wood, cork, and scraps of clothing.

It was an exhilarating experience and the audience enjoyed itself immensely: A wooden horse galloped around a ring propelled by an eggbeater; Dalmatian dogs ran in and out of the spokes of a wheel as the carriage rolled along with a big-bosomed woman, onto whose shoulders a flock of white-paper pigeons descended on wires. There were trapeze artists with hooked hands and heels, along with acrobats who moved from one wire trapeze to another. Throughout it all, the circus master carefully worked the strings and cranks to obtain the desired, unfailingly delightful effects.

Performance art

An evening at Calder's Circus became one of the most popular entertainments in Montparnasse. It was attended and admired by professional circus critics as well as by performers in the world-renowned local circus, the *Cirque Médrano*. (When one knowledgeable critic complained that there was no net under the trapeze acts, Calder responded by installing one.) Most important for Sandy, his Circus became a favorite event among artists and writers and intellectuals.

One of these, the critic Michel Seuphor, came to see it with the Dutch artist Piet Mondrian.

Sound Byte:

We sat munching peanuts, perched on the steep wooden tiers, while Calder, below, in the only corner of his studio that was left free, legs apart, brought out his show. What surprised me most was that this heavy man should be able to manipulate, without breaking them, figurines that appeared so delicate. Not only did he make them turn, dance, jump from one trapeze to another: he had made them himself with his ingenuous fingers.... Calder's Circus captivated us by its attention to detail, by the minute observation of the conventions. And we would wildly applaud the tossing, from one man to another, of the acrobats' white handkerchief or the picking up of the dung after the chariot race.

—MICHEL SEUPHOR, circus critic,
on attending Calder's Circus

This witty example of "performance art" contributed to Calder's development as an artist in two important ways. First, it served as his calling card, as an introduction to the leaders of the Parisian art world, who flocked to his performances and learned to respect and admire him. Also, it furthered his interest in a new means of expressing his artistic talents: sculpture created solely through the use of wire.

Details from *Calder's Circus* (1926–31):

1. *Negress*. Wire, velvet, rhinestones, and hair net on painted wood base. 12 x 8 x 4" (30.48 x 20.32 x 10.16 cm)

2. *Cowboy*. Wire, wood, yarn, leather, cloth, metal, and string. 10½ x 5¾ x 18¾" (26.67 x 14.61 x 47.63 cm)

3. *Clown*. Wire, painted wood, cloth, yarn, leather, metal, and button. 10½ x 9 x 4" (26.67 x 22.86 x 10.16 cm)

4. *Acrobat, Dog, and Kangaroo*. Wire, cloth, painted metal, wood, yarn. (No dimensions)

5. *Prima Donna*. Wire, cloth, metal, wood, cardboard, rhinestones, and thread 12¼ x 5½ x 6" (31.12 x 13.97 x 15.24 cm)

6. *Fanny, the Belly Dancer*. Wire, cloth, rhinestones, thread, wood, and paper 11½ x 6 x 10½" (29.21 x 15.24 x 26.67 cm)

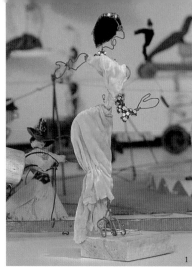

1

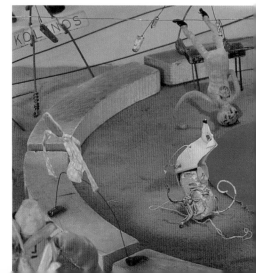

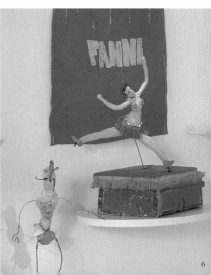

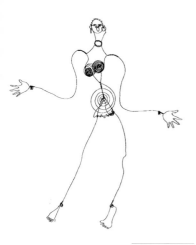

Josephine Baker. 1926. Iron wire
Height: 40" (98 cm)

Musée National d'Art Moderne, Centre Georges Pompidou, Paris

Dancing in the air

Sandy had long used wire as a medium, but it was only when a visitor to his Paris studio suggested that he make sculptures out of wire alone—and not combine it with wood or other materials, as he was doing with his Circus figures—that he began to use wire as a material for sculpture. Working with this strong but flexible material seemed natural to him.

Even Calder's earliest efforts at wire sculpture (i.e., portraits and caricatures that he created in 1926) were a success. One was a forty-inch-tall likeness of **Josephine Baker** (1906–1975), the sensational American music-hall entertainer who had taken Paris by storm. Using a single piece of wire, the sculptor was able to bring her miraculously to life. Bending and twisting the wire, he created her fingers, her toes, her curled hair, her eyes, and her nose. He depicted her breasts and belly by using coils of wire. She acquired a new dimension, an enticing, humorous representation of a vibrant human being, seductively dancing in the air.

With time, the characters depicted in Calder's wire sculptures—essentially three-dimensional forms drawn

in space and evolved from his single-line sketches—grew deeper. In early 1928, he showed some of them to Carl Zigrosser of New York's Weyhe Gallery. Zigrosser agreed to exhibit them at an exhibition that opened on February 20, 1928, and that included some fifteen works. Only two or three of these (including *Josephine Baker*) were sold, but at least two members of the press enjoyed themselves. Murdock Pemberton of *The New Yorker* wrote: "Only geniuses should take art seriously. The others should have more fun with it. Mr. Calder points a moral to those who spend a life hewing stone and then having nothing more than a frog or a water baby. Calder is a deep satirist and shows a human insight missing from ninety-nine per cent of the sculpture turned out today." The reviewer for *Creative Art* was equally enthusiastic: "With wire alone, he has outlined in space a score of subjects ranging from a head of [President Calvin] Coolidge to a sway-back horse…. Their avowed silliness is extremely funny…. He has made of his subjects designs that are not only humorous but telling. And that is more than a mere trickster can do."

Doorstops and nipples

A few days after the closing of the exhibition, two of Sandy's more ambitious works were included in the Twelfth Annual Exhibition of the Society of Independent Artists at New York City's Waldorf-Astoria Hotel. One of them, *Romulus and Remus*, was a humorous interpreta-

tion of the legend of the twins who were said to have founded Rome after being reared and suckled by a she-wolf. (The she-wolf was eleven feet long!) To add an original touch to this work, the sculptor used wooden and rubber doorstops to depict the nipples of the she-wolf.

Early the following year, 1929, another exhibition was held at the Weyhe Gallery, this time of Calder's wood sculptures, most of which had been carved during a summer spent in Peekskill, New York. This exhibition also was well received and further added to the artist's growing reputation in his own country.

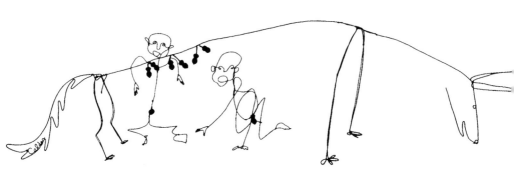

Meeting Miró

Two artists (who later became friends) were especially helpful to Sandy's career. The first of these was the brilliant Spanish painter and sculptor Joan Miró, who had been educated in Barcelona and had come to Paris in 1920. Five years older than Calder, Miró had already made a name for himself when he and the American artist first met at Miró's studio in late 1928. Calder described this initial visit in his autobiography: "He lived in a sort of metal tunnel, a kind of Quonset hut. He was very affable and showed me...a big sheet of heavy gray cardboard with a feather, a cork, and a picture postcard glued to it. There were probably a few dotted lines, but I have forgotten. I was nonplussed; it did not look like art to me."

Calder's first reaction to Miró's work and to the materials he used was not surprising. Still a newcomer to the world of "serious" art, the young American was presumably not yet prepared to accept methods and imagery (already familiar to the Surrealists in Paris) that he himself would later appreciate and adopt. Soon thereafter, Miró attended and enjoyed a performance of the Circus, and the two men began to exchange works. Miró's abstract imagery would profoundly influence the younger artist. As the two men increasingly came to admire each other's work, they shared a common vision as artists and would become close friends for life.

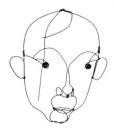

ABOVE
Joan Miró. c. 1930
Wire
11 $^{7}/_{16}$ x 10 $^{5}/_{8}$"
(29 x 27 cm)

OPPOSITE PAGE
Romulus and Remus
1928
Wire and wood
30 $^{1}/_{2}$ x 124 $^{1}/_{2}$ x 26"
(77.47 x 316.23 x 66.04 cm)
Solomon R. Guggenheim
Museum, New York

Pascin at the Dôme

The other artist of great importance to Sandy's career in the late 1920s was **Jules Pascin** (1885–1930), a Bulgarian-American artist who had already built up a following both in America and Europe. A colorful figure, known for the wild Saturday-night parties at which he played host to the artists, models, and prostitutes whose lives he chronicled in his art, Pascin had first come to Paris in 1905 and soon became known for his brilliant drawings and cartoons.

Sandy was introduced to Pascin at the Café Dôme in the fall of 1928 and remembered him as a "small man in a bowler hat." The older artist, possibly because he knew Sandy's father, had visited Calder's exhibition at the Weyhe Gallery and liked what he had seen. Soon after their meeting, the two men became friends, and Pascin, well known for his warmth and generosity, encouraged the younger artist to take part in whatever group exhibitions he could. Pascin also told his influential friends in the Parisian art world about the American sculptor's unique talent. As a result of his fascination, Pascin was

instrumental in arranging Sandy's first solo exhibition in the French capital.

It opened at the Galerie Billiet-Pierre Vorms on January 25, 1929, and Pascin lent his prestige and contributed his unconventional sense of humor to a preface in the catalogue. As in New York, Sandy's exhibition of wire and carved-wood sculptures was favorably noticed by the press, and enough of them were sold to enable him to recover the fee the gallery had charged him to mount the exhibition.

With these solo exhibitions in New York and in Paris behind him, the first three months of 1929 already had been superb. And there was more to come—another solo exhibition in another of the world's great capitals, Berlin.

Taken seriously in Berlin

Calder's first German exhibition, "Portraits, Sculpture, Wire Forms," was held at the Gallery Neumann-Nierendorf in early April of 1929. Sandy had happily accompanied a bundle of his wire sculptures on the train ride to Berlin. The reviews, justifying his enthusiasm, were the most serious and perceptive of his short career. One writer, Emile Szittya, noted that "one cannot describe these works, one must see them." Another critic, Bruno E. Werner, wrote that "one experiences a real pleasure in viewing the work of an American, Alexander Calder, sculptor…. He has imagination and a wonderful sense of humor."

Celebrity

Interest in Calder was so great in Berlin that a short documentary on the man and his work was filmed there in 1929 as part of a series, "Artists at Work." He had become such a familiar figure in Paris that his return to the French capital from Germany was noted in both the *New York Herald* and the *Chicago Tribune.* In Paris, too, he was the subject of a short film that showed him at work in his studio on a wire sculpture of **Kiki de Montparnasse** (1900–1953), a woman of great charm, a famed model and friend of artists, widely known as the "Queen of Montparnasse."

By the middle of 1929, Calder was still struggling to support himself through his art. On June 22, he sailed for America with his circus figures, most likely because of his need to arrange for exhibitions in New York and to solidify contacts there. As luck would have it, the voyage on the *De Grasse* proved to be an unexpectedly successful one since he would meet a woman on board who would become his wife and lifelong devoted companion.

A shipboard romance—and a wedding

Her name was **Louisa Cushing James** (1905–1995). A serene and strikingly beautiful young woman, also an aspiring artist, she was part of a distinguished, well-to-do New England family. She was the grand-niece of the author **Henry James** (1843–1916) and his brother, the philosopher **William James** (1842–1910). When Sandy first saw her, she was walking on the deck of the ship with her father, **Edward Holton James**, who had accompanied her on the visit to Europe. James, Sandy later remembered, had taken his daughter abroad to meet the young intellectual élite, but "all she met were concierges, doormen, cab drivers—and finally me."

The shipboard romance evidently was intense. Louisa's father, whose job it was to watch over his daughter, suffered a severe attack of asthma and was forced to remain in his cabin during much of the crossing. No

OPPOSITE

LEFT
Kiki de Montparnasse
c. 1930
Wire
12 x 10 $^{7}/_{16}$ x 13 $^{9}/_{16}$"
(30.5 x 26.5 x 34.5 cm)
Musée National d'Art Moderne, Paris/Centre Pompidou

RIGHT
Calder drawing Kiki de Montparnasse (the lover of Surrealist photographer, Man Ray) in preparation for making her wire portrait. Paris, May 1929

Alexander Calder
c. 1927

OPPOSITE TOP
Cat. 1930. Plaster
6 x 7 ½ x 4 ½"
(15.2 x 19.1 x 11.4 cm)

OPPOSITE BOTTOM
Donkey. 1930. Bronze
4 ½ x 6 x 1 ⅞"
(11.4 x 15.2 x 4.8 cm)

doubt he was dismayed when his daughter informed him that her ardent suitor was a "wire sculptor."

Free from the surveillance of Mr. James, Sandy and Louisa enjoyed themselves immensely. During the daytime, they played deck tennis and watched the flying fish from the bow of the ship. In the evenings, Sandy donned a tuxedo—not his usual outfit—and enthusiastically showed off his considerable, if somewhat boisterous, skills as a dancer. Their courtship continued after the cruise trip—both in America and in Europe, where Louisa traveled during the summer of 1930. On January 17, 1931, they were married in Concord, Massachusetts, the hometown of Louisa's family. Sandy performed his Circus at the James's house the evening before the ceremony, and when the minister apologized for having missed the performance, the groom consoled him by saying, "but you are here for the Circus today."

An ideal marriage

It was the start of what would be an ideal marriage. The newly-weds were almost miraculously well attuned to one another. Louisa—calm, intelligent, and unfailingly loyal and supportive—was the perfect mate for Sandy. She contributed to their finances and helped to create an atmosphere that gave him the freedom to

work on his art, especially since Sandy was eager for Louisa's family to view him as a professional.

The line between toys and art

For whatever his reasons, Calder had begun to question his art by the late 1920s. He had not yet found his stride and needed a new and more challenging outlet for his creativity. His work had been noticed and praised (Murdock Pemberton of *The New Yorker* had proclaimed in 1929 that Calder was "one of this country's geniuses"), but the acclaim was not enough. The line between the artist's toys and his art was a fine one—and Calder wanted to be taken seriously.

Calder's grandest "plaything" was his Circus, which had been a source of income and, more important, had served as his introduction to the intellectual élite of Paris and New York. The popularity of

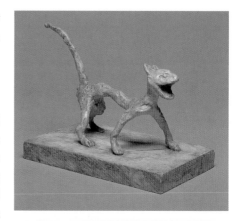

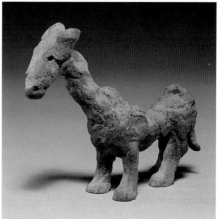

this unique spectacle reached its peak in the latter city following a short piece in *The New Yorker*, informing its readers that "the newest wrinkle in the way of entertainment for parties is an animated toy circus for grown-ups that your guests will simply love."

Although Calder's Circus continued to be successful on both sides of the ocean, the artist was growing weary of his "entertainment." However, his need to supplement his income led the artist to perform the Circus for several years, though as time passed, presentations became increasingly rare.

The Brass family and the goldfish bowl

In December of 1929, an exhibition of Calder's work was held at New York's 56th Street Gallery and featured the artist's paintings, toys, jewelry, wire and wood sculptures, drawings, and textile designs—a variety of work that revealed the artist's ongoing attempts to experiment and search for a medium through which to express himself. Among the pieces shown was one of his most effective and vital wire sculptures, *The Brass Family*. A large sculpture—more than five feet tall—it depicts a strong naked male figure, with six smaller naked figures (both male and female) balanced, brilliantly and with great ingenuity, on his outspread arms. These acrobats are, of course, derived from the sculptor's long-standing fascination with the circus and are part of one of his most endearing masterpieces.

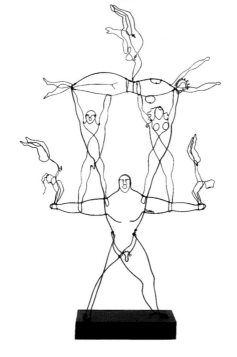

The Brass Family. 1927
Brass wire and painted wood
66 ³/₈ x 40 x 8"
(168.6 x 101.6 x 20.3 cm)

Whitney Museum of American Art, New York.
Photo: Jerry L. Thompson

A last-minute addition proved to be the most surprising and notewor-
thy piece in the exhibition. It was Calder's first formal mechanized
sculpture, *Goldfish Bowl*, perhaps inspired by the large exhibition in an
adjoining gallery of a private collection of 18^th^-century caged mechan-
ical birds. The work shows a goldfish bowl in which two wire fish swim
back and forth at the command of a small wire crank. "Once again
an animal rhythm has caught his eye," wrote the eminent art critic,

museum curator, and early Calder enthusiast James Johnson Sweeney. "This time it was composed within a framed three-dimensional space. The result was a sort of music box of visual rhythms. Its structure was still based on his articulated toys and circus devices. But now, for the first time in his work, we have a composition of movements bound to an immobile base, its primary purpose to satisfy an esthetic sense through rhythm."

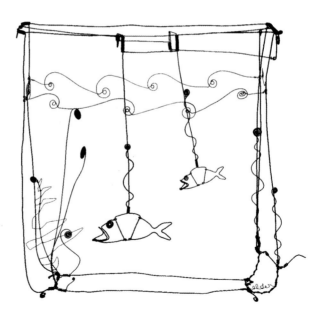

Goldfish Bowl
1929. Wire
16 x 15 x 6"
(40.6 x 38.1 x 15.2 cm)

A visit to Mondrian

Movable sculpture marked a step forward in Calder's development, but the decisive change in his art—which led to all of his future creative development—took place in the fall of 1930, less than one year after this New York exhibition. It followed his visit to the Paris studio of Piet Mondrian, who recently had attended a perfomance of the Circus. The Dutch painter had been a pioneer of abstract art in which shapes, lines, and colors—and their relationships—were valued for themselves and did not imitate or depict any figurative reality. Mondrian's style was based on neoplasticism, a theory that he himself had proposed, which decreed that art should be entirely abstract, that only right angles should be used, and that artists should use only primary colors—red, blue, and yellow—in addition to white, black, and gray.

Piet Mondrian

Sound Byte:
I was very much moved by Mondrian's studio, large, beautiful, and irregular in shape as it was, with the walls painted white and divided by black lines and rectangles of bright color, like his paintings. It was very lovely, with a cross-light (there were windows on both sides), and I thought at the time how fine it would be if everything there moved; though Mondrian himself did not approve of this idea at all.
—ALEXANDER CALDER, on his reaction
to seeing Piet Mondrian's studio

Though Calder came to appreciate and admire Mondrian's paintings, at the time of this visit he was more impressed by the studio itself than by the artist's individual works. This visit, Calder remembered, gave him the shock that converted him to abstract art. It was a "bigger shock, even, than eight years earlier, when off Guatemala I saw the beginning of a fiery red sunrise on one side and the moon looking like a silver coin in the other.... It was like the baby being slapped to make his lungs start working."

Sound Byte:
My mobiles are objects in space. I am a sculptor because I want to avoid telling stories.

—ALEXANDER CALDER

Going abstract

The encounter with Mondrian brought an end to the first period of Calder's life as an artist. From that day on, there would be very few figurative drawings or paintings, and few wood or wire sculptures representing noteworthy familiar figures, animals, acrobats, dancers, or trapeze artists. At the age of 32, he was determined to create abstract works that would be taken seriously. Eager to do so as soon as possible, he went home and tried to paint in a manner that a short time earlier had been completely foreign to him. Painting was not his medium,

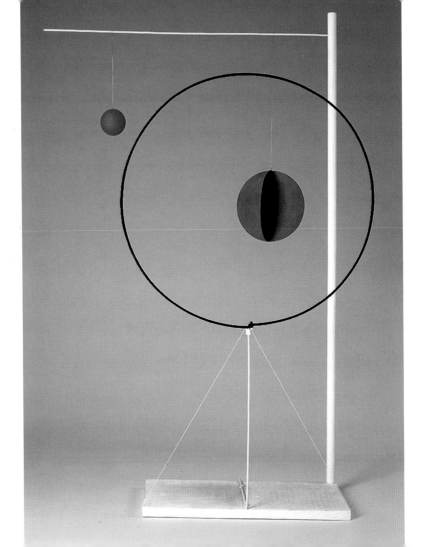

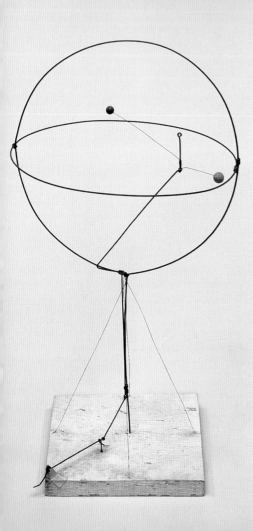

however, and, dissatisfied with the results, Sandy gave up after a few weeks. Still, he remained firm in his resolve to work abstractly and realized that this would take shape in a medium in which he was comfortable: namely, wire or something to twist or tear or bend, something malleable.

The years immediately following Calder's momentous decision were years of intense creative experimentation. His work was his life, and inspiration was a necessity. He believed that there was no point in waiting for it: Inspiration came only through working.

An American in Paris

His first abstract sculptures were exhibited at the Galerie Percier in Paris between April 27 and May 9, 1931. The influential French painter and critic **Fernand Léger** (1881–1955), an early Cubist, wrote in his introduction to the catalogue: "A neo-

plastician at first, [Calder] believed that two colored rectangles formed an absolute. A need for fantasy broke this tie; he started to *play* with materials: wood, plaster, wire—above all, wire. Reaction: the wire becomes taut, geometrical, pure plasticity. At this time—deliberate anti-romanticism, dominated by a preoccupation with balance. Before these new transparent, objective, precise works, I think of [French composer] Satie, Mondrian, Marcel Duchamp, Brancusi, Arp, those uncontested masters of inexpressible and silent beauty, Calder is of this line."

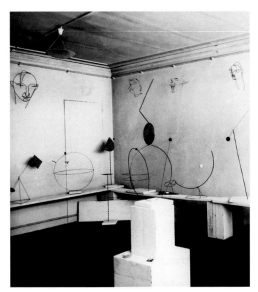

LEFT
Installation of Calder's works at the Galerie Percier, Paris. 1931

OPPOSITE PAGE
Two Spheres Within a Sphere. 1931. Wire, wood, and paint
37 1/2 x 32 x 14"
(95.3 x 81.28 x 35.56 cm)

National Gallery of Art, Washington, D.C.

The exhibit itself contained a number of abstract constructions in wood and wire, spheres and blocks of wood, some of them painted—in strong blues, reds, and blacks. They were simple, spare works, often nothing more than a few pieces of wire twisted into geometrical figures, and one—sometimes two—small wooden balls. When two wire circles intersected at right angles, they formed a sphere, a part of the solar system. These spheres weren't intended to move—although they

were light enough that they might have swayed a little in the breeze. The interacting circular forms seemed to him to have some kind of cosmic or universal feeling. Because of this, Calder later gave them the general title *A Universe*. In the course of an interview, he elaborated: "The basis of everything for me is the universe. The simplest forms in the universe are the sphere and the circle. I represent them by disks and then I vary them. My whole theory about art is the disparities that exist between forms, masses, and movement. Even my triangles are spheres, but they are spheres of a different shape."

The majority of the sculptures exhibited at the Galerie Percier represented a radical departure for Calder. Nonetheless, the show did contain—largely for commercial reasons, since at the time it was far easier to sell accessible figurative works than it was to sell unfamiliar abstract

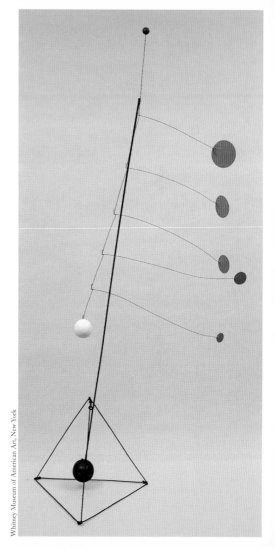

OPPOSITE
Calder in his studio
at 14, rue de la
Colonie, Paris.
Fall 1931

constructions—examples of the artist's earlier works. A circus drawing was shown in the window of the gallery and a few other circus drawings were hung in the gallery itself. These figurative works, reminders of his past, evidently were hung against the wishes of the artist, who feared that they might detract from his latest sculptures. "Pay no attention to the portraits," he wrote on the back of a photo of the show's installation. "The gallery insisted that I include them."

Sound Byte:

I wish I had thought of that myself.
—ALBERT EINSTEIN, after watching *A Universe*
for forty minutes in New York City

Abstraction-Création

In spite of the appearance of a few of his earlier wire sculptures and drawings, the Galerie Percier exhibition unequivocally proclaimed Calder's emergence as an abstract artist. As an affirmation of this, he officially became part of an international group of non-figurative artists—among them **Jean Arp** (1887–1966) and **Jean Hélion** (1904–1987)—who joined together in 1931 under the name *Abstraction-Création* to promote the cause of abstract art. It was the first, and only, group of artists with whom he would formally associate himself.

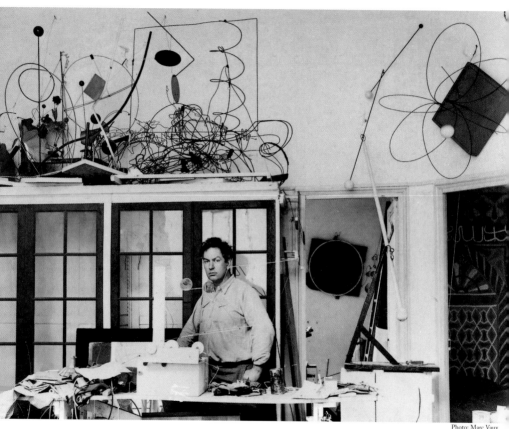

Photo: Marc Vaux

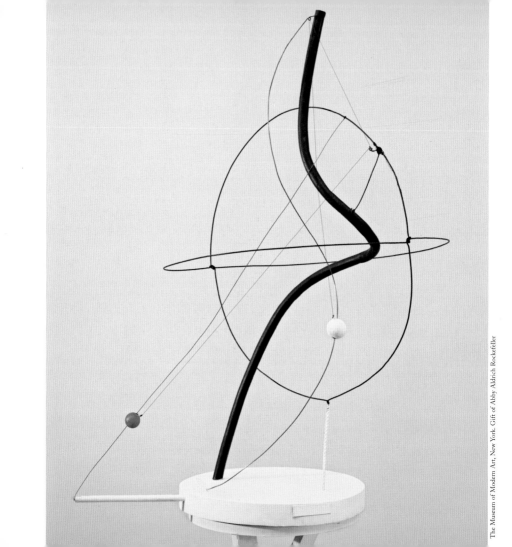

Calder took his membership seriously. For the group's 1932 publication, *Abstraction-Création, Art Non-Figuratif,* he contributed what might be considered his own theory of art. His statement represents the thinking of an intelligent, mature artist who could in no way be considered merely *playful* or *clever:* "How does art come into being? Out of volumes, motion, spaces carved out within the surrounding space, the universe. Out of different masses, tight, heavy, middling—achieved by variations of size or color. Out of directional line—vectors representing motion, velocity, acceleration, energy, etc.—lines which form significant angles and directions, making up one, or several, totalities. Spaces and volumes, created by the slightest opposition to their mass, or penetrated by vectors, traversed by momentum. None of this is fixed. Each element can move, shift, or sway back and forth in a changing relation to each of the other elements in this universe. Thus, they reveal not only isolated moments, but a physical law of variation among the events of life. Not extractions, but abstractions: Abstractions which resemble no living thing, except by their manner of reacting."

Sculpture in motion: the *mobile*

"Why must art be static?" Calder asked an interviewer in 1932. "You look at an abstraction, sculptured or painted, an entirely exciting arrangement of planes, spheres, nuclei, entirely without meaning. It would be perfect but it is always still. The next step in sculpture is motion."

OPPOSITE
A Universe. 1934
Motor-driven
mobile: painted
iron pipe, wire, and
wood with string.
Height: $40 \frac{1}{2}$"
(102.9 cm)

Sound Byte:

A "mobile," one might say, is a little private celebration, an object defined by its movement and having no other existence. It is a flower that fades when it ceases to move, a "pure play of movement" in the sense that we speak of a pure play of light. Most of Calder's sculptures are not imitative of nature. A "mobile" does not "suggest" anything: it captures genuine living moments and shapes them. "Mobiles" have no meaning; they make you think of nothing but themselves. They are, that is all; they are absolutes. There is more of the unpredictable about them than in any other human creation. No human brain, not even their creator's, could possibly foresee all the complex combinations of which they are capable. The object is thus always half way between the servility of a statue and the independence of natural events; each of its evolutions is the inspiration of a moment. A general destiny of movement is sketched for them, and then they are left to work it out by themselves. What they may do at a given moment will be determined by the time of day, the sun, the temperature, or the wind.

—JEAN-PAUL SARTRE, writing
about Calder's mobiles

That next step, for Calder, led to the creation and gradual evolution of the *mobile*—i.e., a sculpture that moves in the air even though it is standing on a base or attached to a wall, or hanging from a ceiling.

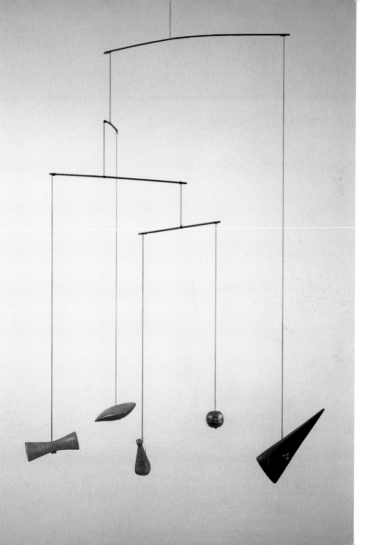

Mobile. c. 1934
Wood, wire, string,
and paint. 39 x 36"
(99.1 x 91.4 cm)

Solomon R. Guggenheim
Museum, New York

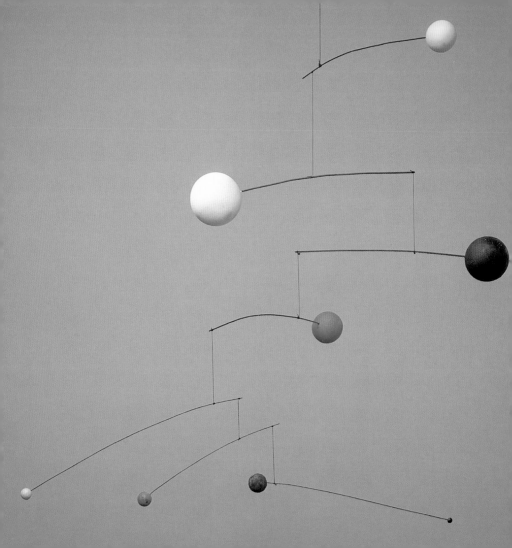

Following the 1931 Galerie Percier exhibition, Calder set to work constructing sculptures equipped with motors, gears, and cranks that made the elements move. Fifteen of these motorized sculptures were shown at the Galerie Vignon in Paris in 1932. Critical reception was good, but the artist was not entirely satisfied since the sculptures' movements were too restricted; furthermore, the machines on which their movements depended were too often in need of repairs. Finally, Calder reached his goal: wind-driven or air-driven sculptures that would respond to the slightest breath—a sigh, a cough, or a whistle. It would be art that moved through the intricate balancing or counterbalancing of the weight within the piece itself.

It is for his mobiles, constructed of wire, wood, sheet metal—and even of glass, string, and found objects—that Calder gained his solid international reputation. It is for these gyrating, spinning, restless works of art that he is probably best known today, yet it would be a mistake to credit him with the discovery of a moving art.

OPPOSITE
Untitled Mobile
1934. Painted
wood, wire,
and thread.
Height: 24$\frac{3}{4}$"
(62.9 cm);
span: 35"
(88.9 cm)

Sound Byte:
Sometimes I do preliminary drawings for my mobiles, but I don't want to know beforehand what I am going to do.
—ALEXANDER CALDER, 1966

Quick detour: kinetic art

Actually, art has swung, jittered, and even flown for many centuries. **Leonardo da Vinci** (1452–1519) drew designs for moving sculptures. Moving elements have been part of the costumes and the dress of a number of different cultures, and the ancient Saxons are said to have carved large circles of stone that were hung from trees.

Before the 20th century, Western sculpture was largely representational or else based on metaphor or myth. Nature, animals, and human beings all looked like what they were in these sculptures, and they usually were carved from stone or wood, cast in metal, or built from clay. The 20th century brought with it the revolution of abstraction, accompanied by the influence of African and Asian art.

As these changes took place, artists who had been trained to think that sculptures had to be solid, unmoving objects began to reconsider this notion. Many conventions were being broken as society grappled with mechanization, wars of tremendous destruction, and growing wealth.

In 1920, the Russian constructivist **Antoine Pevsner** (1886–1962) and his brother **Naum Gabo** (1890–1977) wrote a manifesto, defining their parameters for moving art, which they called "kinetic art." The enormously influential, innovative artist **Marcel Duchamp** (1887–1968)

ABOVE
Alexander and Louisa Calder in front of the Museo del Prado, Madrid. February 1933

OPPOSITE
Red Panel. 1936
Sheet metal, copper tubing, wire, plywood, lead, string, and paint
108 x 60 x 45"
(274.3 x 152.4 x 114.3 cm)

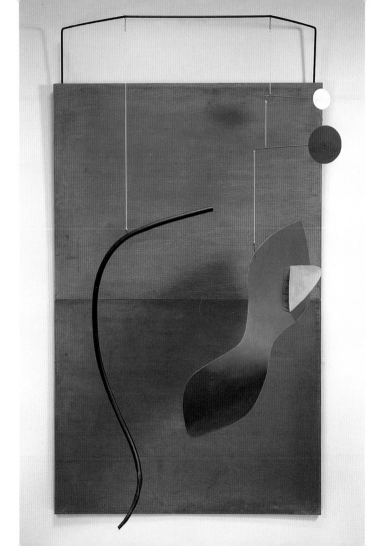

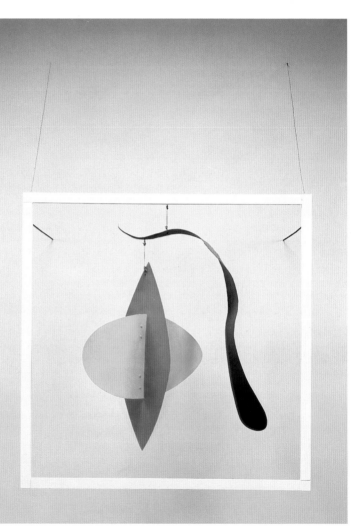

Snake and the Cross
1936. Sheet metal,
wire, wood,
string, and paint
81 x 51 x 44"
(205.7 x 129.5 x
111.8 cm)

was an early experimenter with the kinetic form, for the first time in 1913, when he attached a bicycle wheel upside down on a stool, and which he later called "mobile." (It was Duchamp who suggested the name "mobile" to Calder—significantly, it means both "motive" and "motion" in French.) During the same period, the Italian Futurists spoke of the inclusion of movement in their machine-aesthetic art.

When Calder entered the scene, moving sculpture was certainly not unheard of, but the public at large was not yet accustomed to sculpture that moved in four dimensions—the fourth one being time. With his wit and ingenuity, as well as a delicate sense of balance that astounded and delighted both adults and children, Calder introduced to the world a joyous and entirely new and accessible form of kinetic art. Mobiles are a distinct form of kinetic art, and Sandy Calder remains the one acknowledged master of the field.

Sound Byte:
I think that one of the primary models from which I develop form is the structure of the universe, or part of it. I work from a large live model. When everything goes right, a mobile is a piece of poetry that dances with the joy of life and surprises.

—ALEXANDER CALDER, 1958

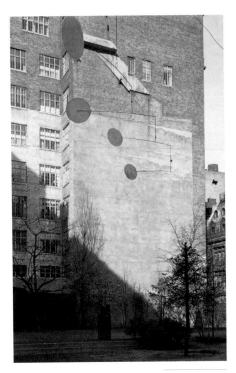

Large Overhead Mobile for Martha Graham 1935. Shown in the exhibition *Alexander Calder* at the Museum of Modern Art, New York. Fall 1943

Movement: theater and dance

Calder's fascination with the mystery, the mechanics, and the spontaneity of movement inevitably extended to the world of dance, an art based on actual motion rather than on the illusion of movement. He had loved social dancing as a young man, and it remained a favorite pastime for the rest of his life. He enjoyed dancing with Louisa, and he enjoyed dancing alone while his wife accompanied him on the accordion.

Working with Martha Graham

One of the sculptor's earliest choreographic collaborations was with **Martha Graham** (1893–1991), the pioneer of modern American dance. She asked him to create an element of decor for a work to be created and performed at Benningon College in Vermont, in the summer of 1935. It was a chance for him to adapt his

mobiles to a live theatrical performance for the first time. The eighteen-minute dance, called *Panorama,* was a sweeping overview of American history, and Calder's job consisted of making overhead discs (mobiles) that were to be pulled and tugged by the dancers by means of lines attached to their wrists. Neither the sculptor's contribution nor Graham's dance was especially noteworthy, but the choreographer had one fond memory of their work together, as expressed in the Sound Byte below.

Sound Byte:

We had no place to rehearse with the mobiles, so we rigged them up in the open field, stretched ropes from tree to tree, and learned to manipulate them to give the illusion of the world of fantasy that Sandy wanted and that enchanted me. The field bordered a public highway, and by a loud blowing of horns we became aware that we had stopped traffic and people were caught up in this fantastic world of trees and meadow and yellow flowers and Sandy and mobiles and dancers.

—MARTHA GRAHAM, dancer and choreographer,
on a performance that included Calder mobiles

Socrates in Connecticut

Sandy went on to work with a number of choreographers, set designers, and stage directors. One of these projects, *Socrates,* was of special interest.

It was the result of a 1936 commission to create a set for a staged version of a symphonic drama, *Socrate*, Erik Satie's musical setting of three short texts by Plato, which the composer had written in 1918. The production of this brilliant and most unconventional work of art was given its American premiere in Hartford, Connecticut, in late 1936. It was sung by two people—a man and a woman, one on each side of the stage—who remained motionless throughout the performance. According to Calder, the singing was the main thing. There were no human dancers or actors, and the "performers" were three moving colored (red, black, and white) elements that moved consecutively and never simultaneously. The cultural historian Roger Shattuck wrote that they "moved within the stage space and filled it completely. One spherical element simply rotated on its own axis. A second smaller disc

FYI: **Sandy and Louisa**—The most important thing about Sandy's life was his marriage. People always said "Sandy and Louisa." They were thought of as one. Sandy was outgoing and jovial and witty, while Louisa was more reserved. She cared about her family, her house, and her garden. She was "proper," well mannered, and charming—as well as very beautiful—and in her own way she was as warm and hospitable as her more ebullient husband. "Louisa is stabile," a friend noted. "She leaves the mobility to Sandy."

twice traversed the entire width of the proscenium on hidden wires; and a third rectangular element lowered itself gradually to the ground, changed from white to black by turning over, and rose again to its full height."

For Calder, "the whole thing was very gentle, and subservient to the music and the words." He would later believe that this "performance" by his mobiles was an important prelude to his future work.

A major public commission

Calder's position as a prominent figure in the world of art was firmly established in 1937 when he received his first major public commission. The occasion was the International Exposition of Art and Technology in Modern Life that was to open in Paris in May of 1937. The site was to be the center of the ground floor of the much-heralded Spanish Pavilion.

It was as a result of his friendship with the Spanish artist Joan Miró that Calder, a foreigner, was able to obtain a commission to place a major work of art in the Spanish Pavilion—one constructed as a symbol of the country's strength by its Loyalist Republican government that was then waging a brutal war with the rebel forces of **Francisco Franco** (1892–1975). Miró had agreed to paint a mural for a wall close to the entrance of the pavilion, and, eager to show his American friend

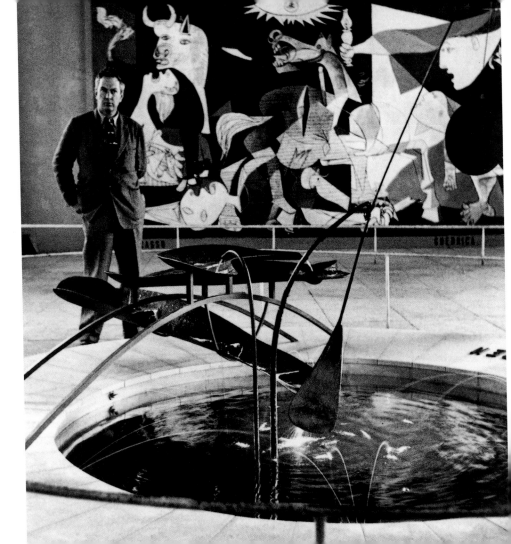

the space assigned to him, took him to visit it some months before the fair opened. Intrigued, Calder immediately envisioned the possibility of creating a moving abstract sculpture of his own that could be installed near Miró's work. The idea turned out to be a good one, but when Miró proposed it to the architects of the pavilion, they rejected it. Calder was not, after all, a Spaniard, and the commission, especially at this time of civil war, must be given to a Spaniard. The organizers of the pavilion wanted to fill this space with a mercury fountain that would dramatize the importance of Spain's mercury mines, but when their search for an appropriate fountain—one designed by a Spaniard—proved fruitless, they turned to Calder for a fresh approach to the subject.

OPPOSITE
Calder with his *Mercury Fountain* in the Spanish Pavilion at the "International Exposition" in Paris. July 1937. (Notice Pablo Picasso's monumental antiwar painting, *Guernica*, in the background.)

Sound Byte:

When it's dinner time.
—ALEXANDER CALDER, when asked how he knew a piece of his had been completed

Calder did not fail them: He created a circular basin into which flowed a stream of mercury that struck and set in motion a suspended mobile. The technical challenges of his *Mercury Fountain* were enormous, but he met them with the skill of a trained technician.

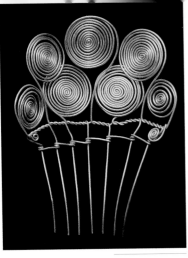

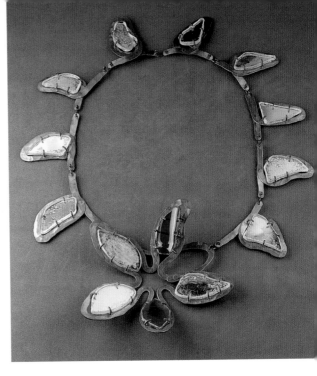

ABOVE
Hair comb, c. 1940. Brass wire
9 5/8 x 7 1/16 x 2 5/8" (24.4 x 18 x 6.6 cm)

RIGHT
Necklace, c. 1938. Brass wire, glass,
and mirror. Outer diameter:
20 1/2" (52.1 cm)

"Is a *stabile* more stable than a statue?"

Alexander Calder is famous today not only for his marvelous mobiles.
He is most probably even better known for his large, powerful *stabiles,*
since a large number of these monumental creations stand in public

spaces and therefore are seen every day by men and woman who never visit museums.

The term "stabile" was first suggested to Calder in 1932 by the Alsatian artist, Jean Arp. Following Duchamp's lead in naming Calder's moving sculptures *mobiles*, Arp recalled the sculptor's first small abstract, non-moving constructions shown at the 1931 Galerie Percier exhibition and asked him, "Well, what were those things you did last year—stabiles?" The word has become a part of the English language. Georges Salles, director of the National Museums of France, offers a fine definition of the term: "Having adopted Jean Arp's unusual appellation, what did Calder himself mean by stability? Is a stabile more stable than a statue? The key to the riddle does not lie there. A stabile conjures up its opposite, the mobile. Its opposite? Yes, since the latter moves, or is moved, and the former is, by definition, static…. One could say that a stabile is a mobile in repose, and a mobile a stabile in action."

Since the early 1930s, Calder had thought about creating abstract sculptures without movable parts, with implied movement, rather than the actual movement of his mobiles. His ultimate goal was to construct large-

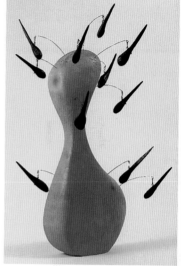

Whitney Museum of American Art, New York
Photo: Jerry L. Thompson

Wooden Bottle with Hairs
1943. Wood and wire.
Overall: 22 ³/₈ x 13 x 12"
(56.8 x 33 x 30.5 cm)

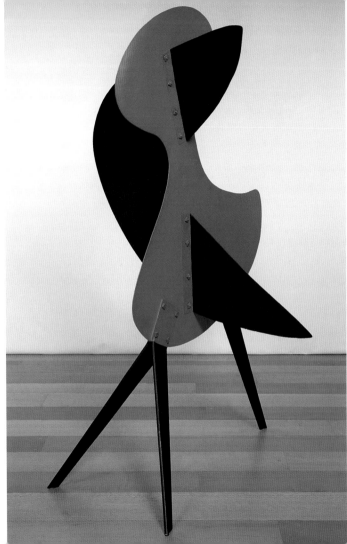

Big Bird. 1937
Sheet metal,
bolts, and paint
88 x 50 x 59"
(223.5 x 127.0
x 149.86 cm)

scale, outsize, monumental sculptures. However, he understood that this would not be easy, since he would require substantial financing. So he began by working on smaller pieces that were either complete in and of themselves or models for what he hoped would eventually become massive sculptures. After cutting strips of metal, he shaped them in a vise between blocks of wood and filed their edges until smooth. As a final step, he bolted the pieces together.

A different procedure

The success of the *Mercury Fountain* brought Calder closer to his goal of obtaining the hoped-for commissions, but it was still several years before he would be offered one. In the meantime, he produced a number of smaller, distinguished stabiles of increasing size. Two were first exhibited in New York in 1937: *Devil Fish* stands somewhat more than six feet tall; *Big Bird,* somewhat taller, is painted in red and black and stands on three legs. Neither is a precise reproduction of its subject, but each one dramatically evokes its subject's image.

In 1940, Calder executed another large stabile, *Black Beast.* This was his largest to date, nearly nine feet high and eleven feet wide. James Johnson Sweeney has described it as overpowering and grim, a "massive, somewhat ominous conception." It is significant among Calder's sculptures in that it led to his use of trained assistants whenever he was working on heavier pieces. An example of this innovation was the commission,

Black Beast (a maquette, or mockup)
1940. Sheet metal and paint
21 x 28 x 17" (53.3 x 71.1 x 43.2 cm)

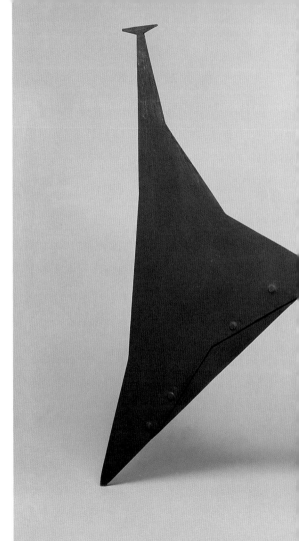

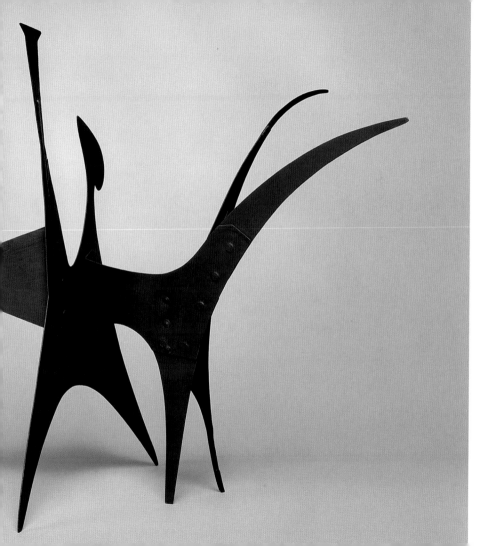

Alexander Calder
1940

OPPOSITE PAGE
Calder's studio
in Roxbury,
Connecticut
1941

offered in 1958 by Eliot Noyes, a Connecticut architect, for a copy of the original *Black Beast*. In order to accomplish this, the sculptor saw the need to use a heavier material—a one-quarter-inch iron plate—that he could not cut by himself with hand-held tools. Thus, he needed the help of skilled workmen, employed at metal shops, to work on the materials—always under his own supervision, of course.

Calder described this new procedure: "I make a little maquette [i.e., a model] of sheet aluminum, about fifty centimeters high. With that I'm free to add a piece, or to make a cutout. As soon as I'm satisfied with the result, I take my maquette to my friends [at the metal shop], and they enlarge the maquette as much as I want. When the enlargement is finished, provisionally, I go to add the ribs and the gussets or other things which I hadn't thought of. After that, they work out my ideas on the bracing. And that does it."

> **FYI: Calder's work habits**—Sandy kept a regular work schedule. Each morning after breakfast he went to his workshop and stayed there from nine until one o'clock, when the family came together for lunch. Following lunch, he returned to his studio until five or six o'clock, when he frequently joined his son-in-law Jean Davidson for a game of billiards.

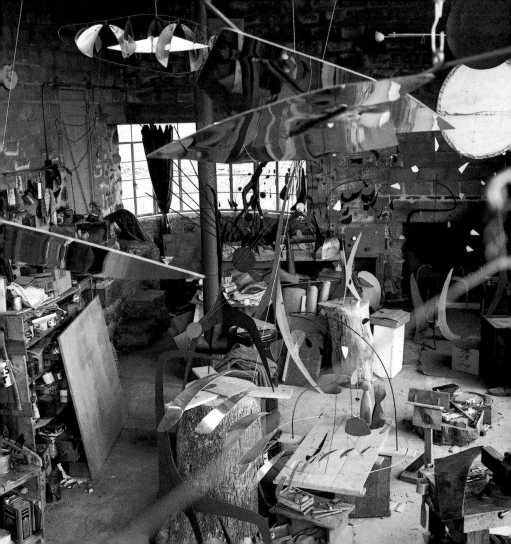

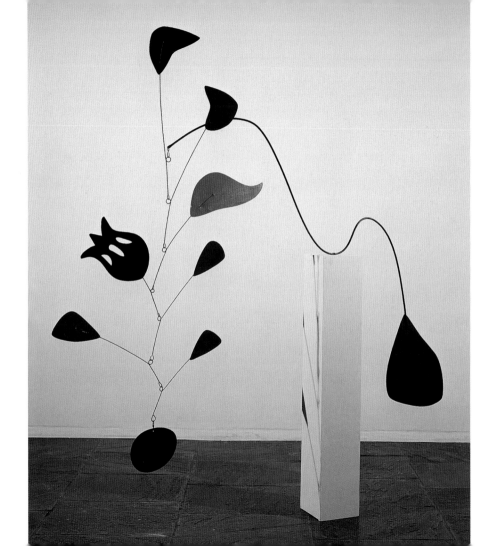

Please, no symbolism

As early as 1952, working on a commission for **Nelson Rockefeller** (1908–1979), Calder had learned practical ways to construct very large sculptures, ones that required hard-to-handle materials. This project supplied him with the funds needed to do so. By using several metal shops, he was able to work on several different sculptures at the same time. In one shop, he was working on *.125*, a forty-five-foot mobile for

FYI: **Calder's homes**—For most of their mature years, Sandy and Louisa divided their time between the small town of Roxbury, Connecticut, and the small village of Saché, near Tours, in France's Loire Valley. The Roxbury home, bought in 1933, had been a farmhouse and underwent several renovations throughout the years. The Saché property was purchased in 1953 with the help of Jean Davidson, the Calders' future son-in-law and Sandy's close friend and confidant, who exchanged a dilapidated 17th-century stone house close to his own home for three Calder mobiles. Though separated by an ocean and architecturally different from one another, both of these homes were transformed unmistakably into "Calder homes." Both were set in the midst of rolling hills and flowers, surrounded by art that Sandy had completed or that was in progress, as well as by lawns embellished with stabiles and mobiles.

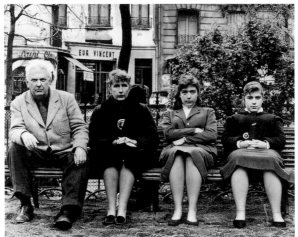

Photo: Agnès Varda

New York's JFK Airport (then called Idlewild). In another, he was making *Whirling Ear,* a motorized monumental sculpture for the pool in front of the United States Pavilion at the 1958 Brussels World's Fair. In the third, he was involved in an especially ambitious project—the construction of the head of a large, thirty-foot-high standing mobile, *La Spirale*, for the UNESCO headquarters building in Paris. Consisting of a large stabile base surmounted by a wind-driven series of cantilevered mobile elements, it remained one of Calder's favorite pieces, as well as one of his largest standing mobiles. As with all of his abstract sculptures, it was impossible for him to discuss it or give it any profound, complex meaning. When asked

92

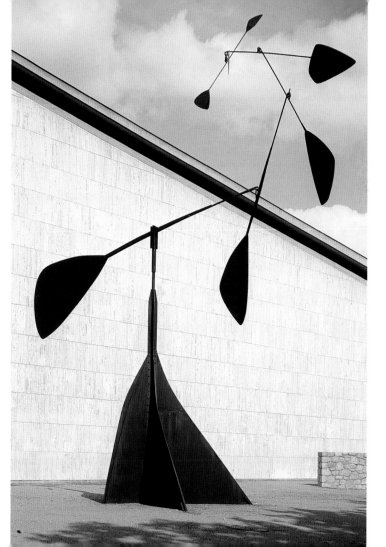

La Spirale, at the Palais de l'UNESCO in Paris. 1958 Painted steel Height: 30 feet (9.14 meters)

in 1959 by an interviewer whether there was any symbolic meaning in the piece, he looked puzzled for a moment and then answered: "Well, it goes up, it's something like a flame." He then hesitated and, according to the interviewer, suddenly grinned happily and continued, "But there is no history attached. Sorry." At this point, Louisa explained that her husband was "about as unsymbolic a person as I know."

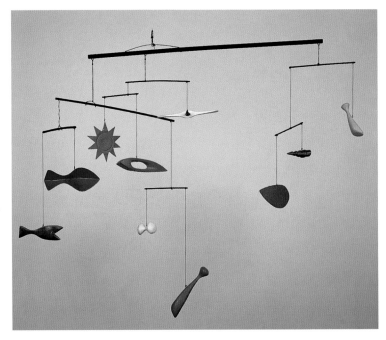

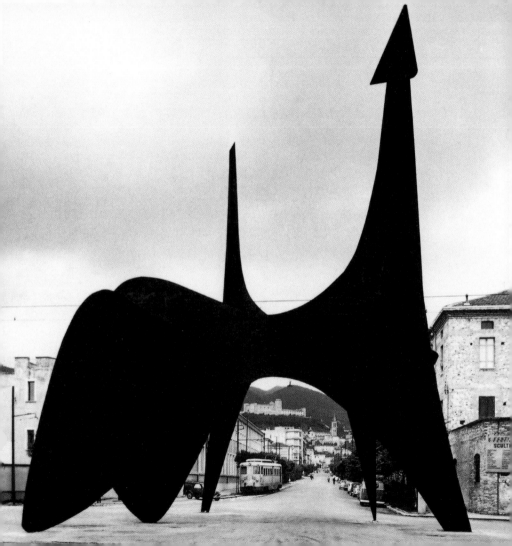

A monumental sculpture

In 1962, Calder was invited to create his first monumental stabile for an urban setting. The commission was offered to him by the small hill town of Spoleto, Italy, at the urging of Giovanni Caradente, who was serving as chief organizer of a huge outdoor sculpture exhibition, "Sculpture in the City," to be held as part of the Umbrian town's Festival of Two Worlds during the summer of 1962. Calder's gigantic work, sixty feet high and weighing some 30 tons, was built by an Italian shipbuilder, following the sculptor's maquette. Named *Teodelapio*, after a Duke of Spoleto, its purpose was to serve, temporarily, as a symbolic entrance to the exhibition and to the town itself. Though many observers felt it resembled a dynamic, powerful animal—perhaps an enormous cat, with its tail raised high—the sculptor characteristically refused to discuss its meaning. He did, however, offer one comment to an artist-friend, Robert Osborn: "People keep giving it phallic meaning," he said. "I wasn't aware of any such influence, but that might give it its nice force." Following the close of the exhibition, Calder donated *Teodelapio* to the town of Spoleto.

OPPOSITE
Teodelapio in Spoleto, Italy. 1962 Painted steel Height: 60 feet (18.25 meters)

High speed

Another of Calder's monumental stabiles achieved another "first" when, in August of 1967, the sculptor was commissioned by the city of Grand Rapids, Michigan, to create a sculpture to be placed in the

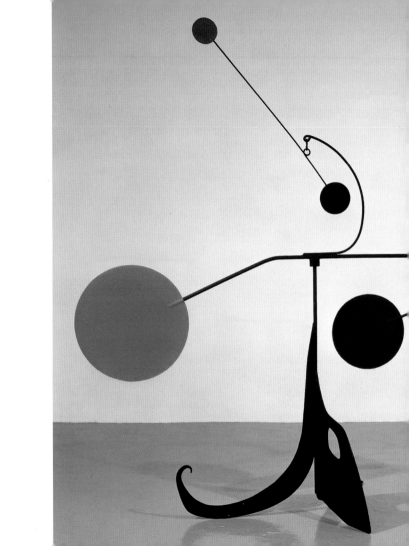

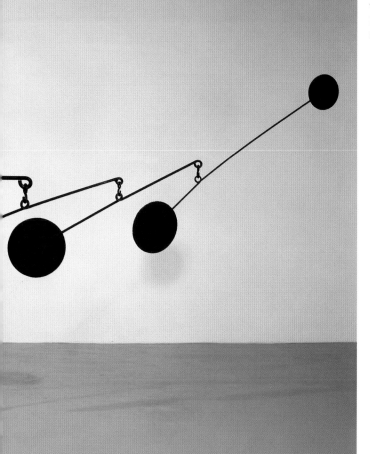

Myxomatose. 1953
Sheet metal, rod,
wire, and paint
101 x 161"
(256.5 x 408.9 cm)

OPPOSITE
*La Grande
Vitesse* ("High
Speed"), in
Grand Rapids,
Michigan
Painted steel
1969. A monu-
mental stabile

center of the city, making it the first sculpture to be funded by the public-art program of the National Endowment for the Arts. The government's agency contributed a matching grant of $45,000, and the remaining funds were raised locally.

The project was an enormous success, and the people of the furniture-manufacturing city embraced it enthusiastically when it was inaugurated on June 14, 1969, accompanied by music created for the occasion by the American composer **Aaron Copland** (1900–1990). *La Grande Vitesse* ("High Speed")—a pun on Grand Rapids—dominates the center of the city. Forty-three feet high, thirty feet wide, and fifty-four feet long, it stands like a giant red plant before a black glass building, part of a complex of city and county office buildings. It has become an integral and essential part of the city, and the square on which it is located is now called Calder Plaza.

Urban outfitter

During the 1960s and 1970s, Calder's enormous stabiles were installed in public places throughout the world, enlivening and enriching the landscapes of the cities and towns they inhabited. The list is a tremendous one: New York, Philadelphia, Kansas City, Cambridge, Albany, Des Moines, Washington, Houston, and Los Angeles, to mention but a few of them in the United States. In Europe, these huge, mysterious,

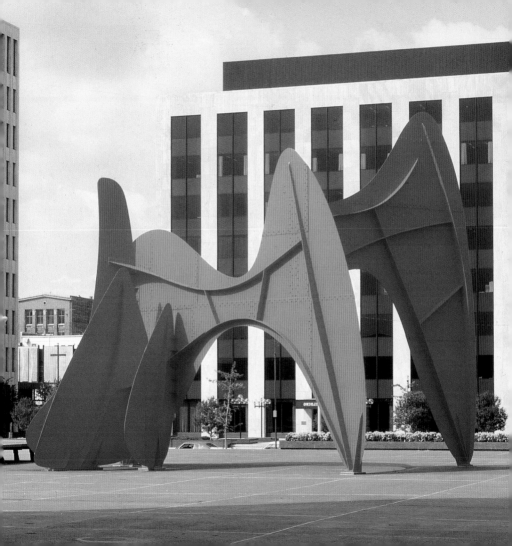

and often brilliantly painted shapes have embellished an equally large number of towns and cities: Brussels, Rotterdam, Amsterdam, Berlin, Stockholm, Paris, Grenoble, and others.

Calder's understanding of and ability to collaborate with some of the 20th century's greatest architects—**Le Corbusier** (1887–1965), **Marcel Breuer** (1902–1981), **Philip Johnson** (b. 1906), **Mies van der Rohe** (1886–1969), and **I. M. Pei** (b. 1917) among them—accounts in part for the proliferation of his giant sculptures, which humanized their frequently dark and severe postwar urban buildings and industrial complexes. Most important, however, Calder's popularity grew increasingly because his public sculptures were breathtakingly beautiful. Despite their size—sometimes 60 or 70 feet high and weighing more than fifty tons—they provide a light, graceful, and witty touch to the existence of those fortunate enough to live among them.

Sound Byte:
His work is his religion. He is always expressing his sense of pleasure and his joie de vivre. He isn't an unhappy man. He isn't tormented. He enjoys life.

—LOUISA CALDER, speaking about her husband
with art critic and professor Selden Rodman

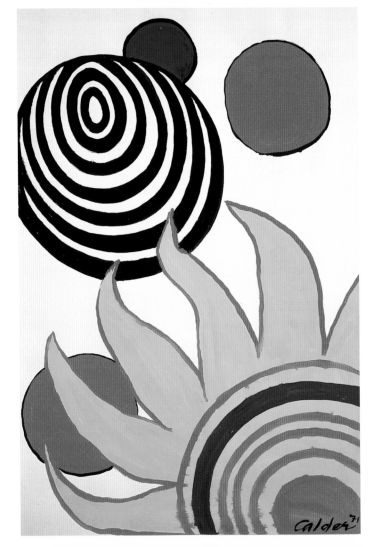

Alexander the Great

If, as Jean-Paul Sartre wrote, the mobile was a small, private celebration, then by the same token Calder's stabiles can be considered large, public celebrations. Calder's life, too, deserves to be called a celebration—of art, beauty, and human creativity. It was therefore fitting that Calder the man and artist was joyously celebrated in Chicago, Illinois, on October 25, 1974. The day had been proclaimed Alexander Calder Day—"a great day for ChiCalder," a newspaper headline announced. The occasion was the inauguration of *Flamingo*, one of the sculptor's

OPPOSITE
Untitled. 1971
Gouache on paper
43 ½ x 29 ½"
(110.5 x 74.9 cm)

> *FYI: The private Sandy*—He had no hobbies and very few interests outside of his work. He was not a reader, and he rarely visited art museums. He did not attend concerts because that would mean sitting still for too long. However, Sandy and Louisa were interested in politics; they expressed their opposition to the Vietnam War both publicly and angrily. His passion was people. He loved to be surrounded by friends, and he and Louisa gave superb parties, where they danced and drank. Everyone was welcome in their home at all times. Sandy did not talk much; he believed that one sentence might suffice for an entire day. He was known to fall asleep at his parties. Some believed that it was his way of avoiding boring conversation.

most delightful, vigorous stabiles. It was installed on the city's Federal Center Plaza, in front of a federal office building that had been designed by Mies van der Rohe. Reflected in the tinted glass of the building's tower, it is a massive, exuberant representation in structured steel of a giant (53 feet high) crimson-red (or Calder red, as it has come to be known) bird, perched on long, spindly legs, its beak turned downward to the ground.

> **FYI: The Calder household**—The Calders were a surprisingly "normal" family. Sandy and Louisa lived with their two beautiful daughters, Sandra (later Sandra Davidson), born in 1935, and Mary (later Mary Rower), born in 1939. The family was united in their belief that Sandy was a brilliant artist—to be respected as well as loved. Sandy, though childlike himself, was not always at ease with his children—nor they with him. He enjoyed making fun of them, and his teasing was sometimes a bit difficult for his children to understand. Still, no one questioned his love for them or their love for him. This included his most devoted grandchildren, Andrea and Shawn Davidson, and Holton and Alexander Rower. The entire family hated ostentation and lived simply—they showed no interest in luxurious cars or clothing. Neither the townspeople of Roxbury nor those of Saché realized that the rather unconventional man who lived among them was a well-known artist.

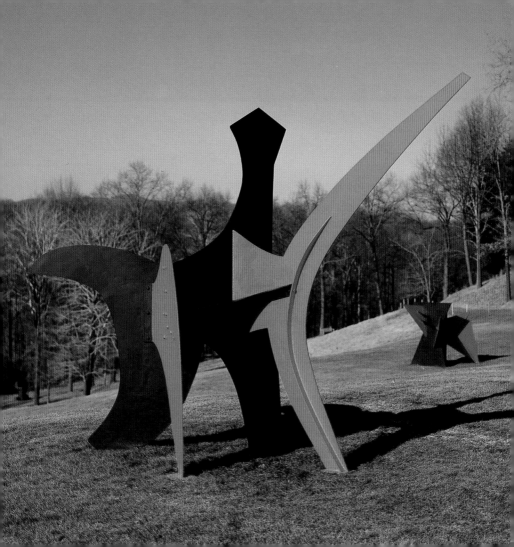

Chicago welcomed Calder with roaring enthusiasm by staging a joyful circus parade in his honor. Bands played, calliopes whistled, and clowns turned cartwheels. There were unicyclists, real and stuffed animals, and a man in a gorilla suit riding in an antique red-and-gold circus wagon. Several thousand multicolored balloons sailed in the sky and tens of thousands of celebrants lined the streets to greet the artist, who rode in the parade, perched on top of a brightly painted circus wagon drawn by forty horses.

Sound Byte:
Calder is an original, the outstanding creative mind of the 20th century.
—LOUISE NEVELSON (1900–1988), sculptor

In the end, a ringmaster introduced the honoree to the cheering crowd as "Alexander the Great—Sandy Calder." But Sandy made no speech. His work spoke for him. He had to go on to the lobby of the Sears Tower, where his thirty-three-foot-high, red-yellow-blue-and-black motorized wall mural was to be dedicated. In addition, he planned to visit a retrospective exhibition of his work at the city's Museum of Contemporary Art.

Other honors followed. On December 18, 1974, he received the Grand Prix National des Arts et des Lettres from the French Minister of

Culture. In early 1975, he was awarded the United Nations Peace Medal—and Louisa received the Woman of the Year Award from the World Federation of the United Nations Associations. During early October of 1976, it was Philadelphia's turn to honor its native son by organizing an Alexander Calder Festival of its own. The highlights included the dedication of *White Cascade,* a monumental mobile, at the Federal Reserve Bank.

On October 14, 1976, a retrospective of Calder's work opened officially in New York City. The celebration dinner was held six days later, but

OVERLEAF
Untitled (a.k.a. *East Building Mobile*), located in the National Gallery of Art, Washington, D.C. 1976. Aluminum honeycomb, tubing, steel, and paint 29'10" x 76' (9.08 m x 23.16 m)

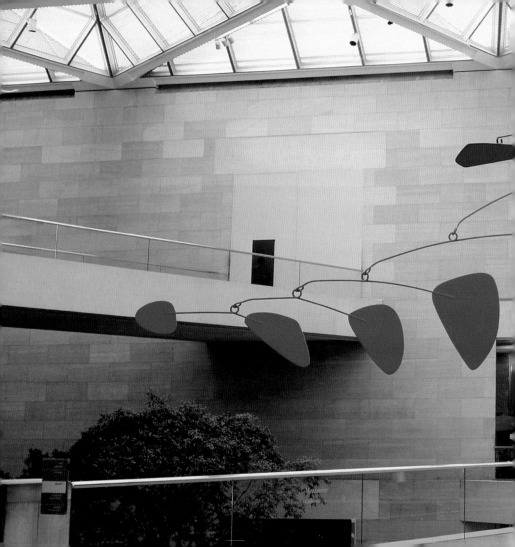

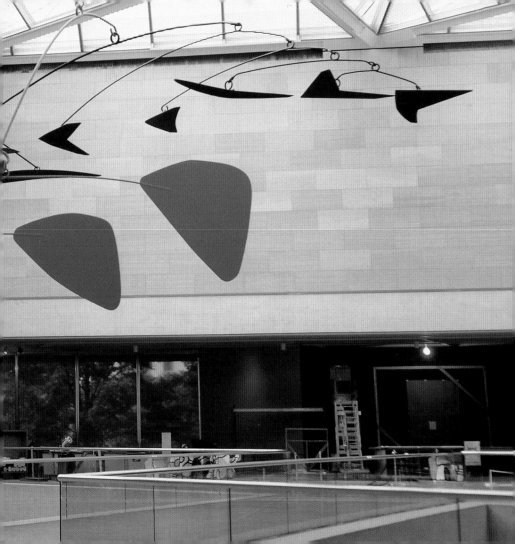

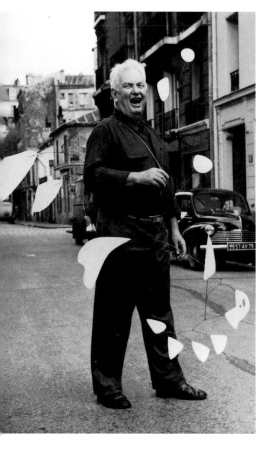

on November 11, 1976, the artist died of a heart attack at the New York home of one of his daughters, Mary Calder Rower. Though he had been in only fair health—he suffered from Parkinson's disease—his death was unexpected. Sandy had seemed indestructible. He was as stubborn as a tree, but equally responsive to the wind's motion; as warm as the friendly bear that walked within him. His family and friends will miss his dancing and his gruff sleepy-bear character, as well as his eternal red shirt so symbolic of his personal warmth and his sense of rhythm, fun, and capacity for enjoyment—essential elements of his life as well as his art. Alexander Calder's generous, sympathetic humanity will endure as part of his personal and creative legacy. James Johnson Sweeney, then curator at the Museum of Modern Art, seized the essence of Calder's genius when he wrote, "Though the dancer is gone, the dance remains."